TURNER

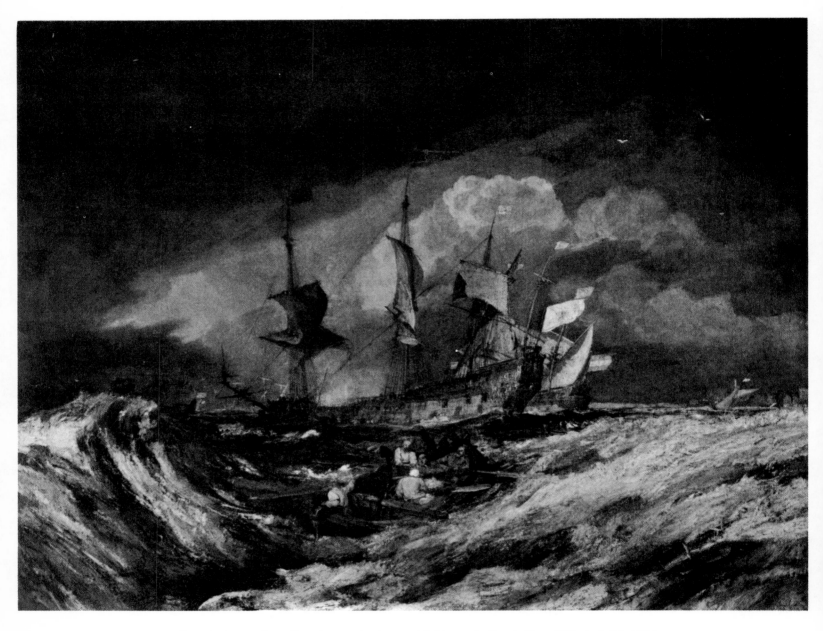

Frontispiece. *Boats Carrying out Anchors and Cables to the Dutch Men of War in 1665.* 1804.
Oil on canvas, 40 x 51½″ (101.6 x 130.8 cm.). The Corcoran Gallery of Art, Washington, D.C., W. A. Clark Collection

JOSEPH MALLORD WILLIAM
TURNER

JOHN WALKER

Director Emeritus, National Gallery of Art, Washington, D.C.

HARRY N. ABRAMS, INC., PUBLISHERS, NEW YORK

Library of Congress Cataloging in Publication Data
Walker, John, 1906 Dec. 24–
Joseph Mallord William Turner.
Concise edition of the author's Joseph Mallord William
Turner originally published: New York: Abrams, 1976.
1. Turner, J. M. W. (Joseph Mallord William), 1775–
1851. I. Turner, J. M. W. (Joseph Mallord William),
128p. 1775–1851. II. Title.
ND497.T8W34 1982 759.2 82-11578
ISBN 0-8109-5331-5 (EP)
ISBN 0-8109-1679-7 (HNA)

CONTENTS

ACKNOWLEDGMENTS

A number of people have been kind enough to help me with this book, but to several I owe a special debt of gratitude. First, to Mrs. Carolyn Wells, who typed and retyped my manuscript, did extensive research for me, straightened out my footnotes and added to them, and saw the book through the press. Without her assistance my task would have been formidable and unbearably tedious.

I am also indebted to my British colleagues at the Tate Gallery and the British Museum, especially Martin Butlin, John Gere, and Andrew Wilton.

It is always tiresome for collectors to have their privacy invaded for the transparencies which are inevitably needed. For their patience and kindness in this regard I would like to express my appreciation to Paul Mellon, Nicholas Horton-Fawkes, and Mrs. G. Macculoch Miller.

Needless to say, this book could not have been written without bibliographical facilities, and I would also like to thank the librarian and staff of the National Gallery of Art's library in Washington, and to mention the cooperation and helpfulness of the staff of the London Library, that wonderful institution without which so many authors living in London would be helpless.

JOHN WALKER

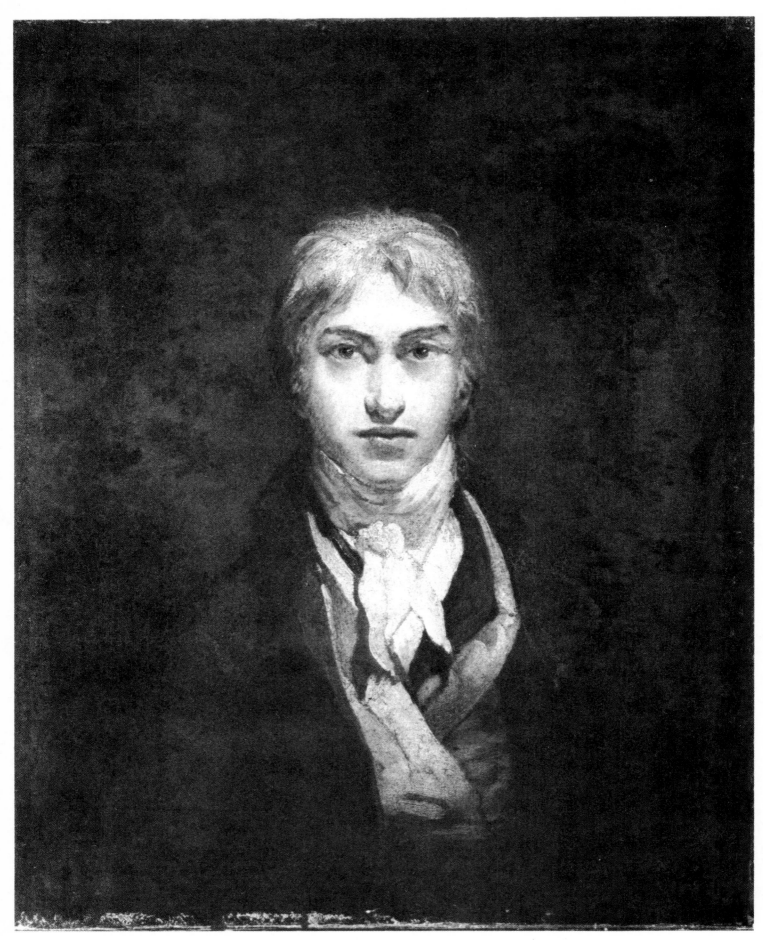

1. *Self-Portrait.* c. 1798. Oil on canvas, 29 x 23″ (73.7 x 58.4 cm.). Tate Gallery, London

INTRODUCTION

J. M. W. Turner wished to be elusive, and fate, as far as biographies are concerned, cooperated. John Ruskin, the logical choice, refused to be the artist's biographer, regarding such a task as unworthy of his genius. Ruskin wished instead to devote himself to the criticism and interpretation of Turner's pictures; he expected others to rush forward to chronicle the life of the most famous painter of his generation. He was wrong. During the six years following Turner's death in 1851, only three short sketches were published. Then Walter Thornbury, a journalist, versifier, and novelist, saw his opportunity. In 1862, after more than four years of research, he produced a two-volume work, *The Life of J. M. W. Turner, R.A.* While this book has been generally disparaged, Thornbury, from interviews with friends and acquaintances, did succeed in turning up the basic biographical material about Turner. Fortunately for the painter's sense of privacy, Thornbury, who had access to contemporary accounts, has been so thoroughly belittled that whatever he had to say about Turner's personal life has been to a great extent ignored or discounted.

To penetrate the personality of any artist is difficult, but Turner is particularly enigmatic. Secrecy was part of his nature. He avoided entangling friendships, rejected any matrimonial involvement, frequently used assumed names, and sometimes concealed where he was living. Doubtless these precautions and deceptions grew out of his passionate desire for independence. This desire seems to have been a motivating force throughout his life.

Turner's second major characteristic, avarice, was also related to his need for independence. He had an obsessive fear of poverty and its concomitant: loss of freedom. In the words of Sir Walter Scott, "Turner's palm is as itchy as his fingers are ingenious, and he will, take my word for it, do nothing without cash and anything for it."[1] This is unfair. Turner never sacrificed his artistic integrity for any amount of money, and toward the end of his life he would not part with those pictures he particularly loved, regardless of how much he might have obtained from their sale. Effie Millais, when she was married to Ruskin, came to know Turner quite well, and she reports that he once showed her a blank check "which had been sent to him to fill in to any amount he chose if he would sell one of his pictures, but he laughed at the idea and sent back the cheque immediately."[2]

There is no doubt, however, that Turner was parsimonious. Money in the Funds (British government bonds) meant the fulfillment of his dearest wish—to be dependent on no one. There was also a strong hereditary inclination toward frugality. He once said, "Dad never praised me for anything except saving a halfpenny."[3] He seems to have taken an almost aesthetic pleasure in contemplating the government bonds he accumulated. At his death his estate was valued at just under £140,000, or $700,000.[4] He needed some of this wealth, as we shall see, to be able to follow singlemindedly his own pursuits—to travel, to observe, to paint as no one had ever painted before.

Turner's efforts to preserve his privacy were largely suc-

cessful, although as early as 1809 his close follower, the painter Sir Augustus Callcott, is quoted in the diary of the Academician Joseph Farington as saying that the artist was living with Sarah Danby, the widow of the composer John Danby.[5] But with the probating of his will, it was revealed that Turner, while ignoring numerous distant relatives, had recognized with sizable bequests three women with whom he undoubtedly had some intimacy: Sarah Danby, her niece Hannah Danby, and Sophia Booth. He also left annuities to two of Sarah's children, Georgiana Danby and Evelina Danby "Dupree" or Dupuis, who were quite probably his own daughters. Sarah apparently predeceased Turner, as her legacy was revoked and later codicils refer only to Hannah, who, he plainly states, is "residing with me."[6]

Turner must have thought that his transgressions were his own business; and Ruskin and A. J. Finberg (the author of

2. James Wykeham Archer. *Turner's Birthplace, 21 Maiden Lane, Covent Garden.* 1852. Watercolor, 14 x 8⅝" (35.5 x 22 cm.). British Museum, London

The Life of J. M. W. Turner), who knew more about the artist than anyone else, were probably right to respect his privacy. Nevertheless Ruskin was troubled. In writing about a drawing, he expressed his puzzlement. He said that Turner "saw, and more clearly than he knew himself, the especial forte of England in vulgarity...with all this, nevertheless, he had in himself no small sympathy; he liked it at once and was disgusted by it; and while he lived in imagination in ancient Carthage, lived, practically, in modern Margate. I cannot understand these ways of his."[7] Although these words were written as a criticism of a picture, they describe Ruskin's bewilderment when faced with the painter's way of life. Since he was named an executor of Turner's will, Ruskin had to know about Evelina Dupuis, in her own words "the surviving daughter of an artist of such repute,"[8] to whom the Court of Chancery required the payment of an annuity, but he is too reticent in his autobiography to tell us what a shock this must have been.

Ruskin was even more shocked by Turner's obscene pictures. Frank Harris, in his autobiographical volume, *My Life and Loves,* claims to have had an interview with Ruskin about 1880, in which this friend, whom Turner trusted enough to name an executor of his will, said that he had burned the indecent drawings. Harris's very entertaining account is given in a footnote.[9] Placing little reliance on the veracity of the author of *My Life and Loves,* I was inclined to doubt this lurid tale of a horrible auto-da-fé, until in 1975 it was confirmed by the discovery of a letter of 1862 written by Ruskin to R. N. Wornum in which he states categorically that the obscene drawings were burned by Wornum "in my presence."[10]

Thus the prudery of two Victorians has prevented our ever having full knowledge of Turner's genius as a draftsman of the human figure.

Perhaps even Charles L. Eastlake, the director of the National Gallery, and one of the compilers of the inventory of Turner's works, felt that Ruskin and Wornum had gone too far. In 1861 Eastlake was testifying in the House of Lords on the government's failure to carry out the terms of Turner's will. Queried about a rumor that there were indecent drawings in the Turner Bequest, he answered that he came "to a few sketchbooks fastened up and labeled by the Executors 'not fit for general inspection' or words to that effect. We did not open them so that I cannot speak of them from my own observation."[11] He concealed what he must have known since 1858, that these sketchbooks no longer existed. One of the peers may have asked to see these libidinous drawings, and when they could not be produced, Ruskin may have been forced to write the explanation of what had happened. The destruction of the greater part of Turner's figure drawings is a crime for which Ruskin deserves unqualified condemnation.

Finberg's reticence about Turner's licentiousness, in view of the fact that his biography of Turner was published in the 1930s, is more difficult to understand. On his painstaking and superb research all subsequent biographies of the artist are based. Yet though Finberg, like Ruskin, knew of Evelina Dupuis, he says there is no evidence that Sarah Danby "was anything more than a housekeeper."[12] He held to the theory that all her children were from her marriage. A Victorian

3, 4. Sketchbook drawings of embracing couples. c. 1834.
Pencil and watercolor, British Museum, London

biographer, Philip G. Hamerton, was more candid. He wrote, "We all know the pictures of Titian and his mistress, and his portraits of her, yet nobody talks of the immorality of Titian; but Turner's arrangement with Mrs. Danby and Mrs. Booth give acute pain to our sense of propriety because they seem more degrading...in Turner's conduct in this respect there were two offenses, one against morality and the other against good taste."[13]

It seems strange to us that the "morality" and "good taste" of an artist should be considered important, but both weighed heavily in nineteenth-century judgments. This explains to some extent why Turner was never knighted. Though in politics he was a liberal and in the Academy opposed the royal prerogative, he was not considered hostile to the court; and George IV seems to have admired his landscapes, comparing them to the works of Claude Lorrain, and commissioning him to do a picture of the victory at Trafalgar (fig. 5) for St. James's Palace. But neither that monarch nor his successor, William IV, granted the artist a knighthood. Turner must have found it even more galling to be passed over by Queen Victoria, who, on coming to the throne, knighted his disciple, Augustus Callcott, and such now forgotten artists as Richard Westmacott, a sculptor, and G. S. Newton, a miniaturist. The painter Edwin Landseer, although he eventually accepted a knighthood, to everyone's surprise refused the honor the first time the queen offered it to him. One likes to think that he did this because he felt strongly that the most eminent painter in the history of British art had been inexcusably slighted.

To Ruskin, Turner's genius was preternatural. In his journal of 1840 he noted, "Introduced today to the man who beyond all doubt is the greatest of the age; greatest in every faculty of the imagination, in every branch of scenic knowledge; at once *the* painter and poet of the day, J. M. W. Turner. Everybody had described him to me as coarse, boorish, unintellectual, vulgar. This I knew to be impossible. I found in him a somewhat eccentric, keen-mannered, matter-of-fact, English-minded gentleman; good-natured evidently, bad-tempered evidently, hating humbug of all sorts, shrewd, perhaps a little selfish, highly intellectual, the powers of the mind not brought out with any delight in their manifestation, or intention of display, but flashing out occasionally in a word or a look."[14]

Ruskin was young and inclined to hyperbole, but this characterization of Turner is, for the most part, corroborated by others. Certainly he was, as Ruskin observed, "highly intellectual." He read the most recent, somewhat abstruse scientific works related to visual matters, often writing notes in the margin, and experimented with a prism to study the spectrum. It is extraordinary that given his background and education he should also have shown such erudition in the subject matter of many of his pictures and such wide reading in his choice of poems to elucidate the themes of his works. His own poetry, the unfinished epic *The Fallacies of Hope,* is, as far as one can judge from a few fragments, a failure, but it does contain some notable lines. The syntax of his prose, however, in letters as well as lectures, is deplorable.

Nevertheless it is not unreasonable to consider that Turner was "the greatest in every branch of *scenic* knowledge." If superiority in art can be measured, his attainments are more measurable than those of most painters, since in many of his canvases he deliberately challenged earlier masters: Claude, Poussin, Ruisdael, Cuyp, and his two English predecessors, Wilson and Gainsborough; and in these competitions he seems the winner, at least by modern standards. To master the styles of earlier artists and to outdo them is remarkable, but it is more amazing to leave behind canvases which compete with the work of artists yet unborn. This Turner did. A century before the New York School existed, there were found in his studio numerous oils and watercolors which are virtual abstractions, experiments, if that is what they were, unprecedented in the rendering of light and color.

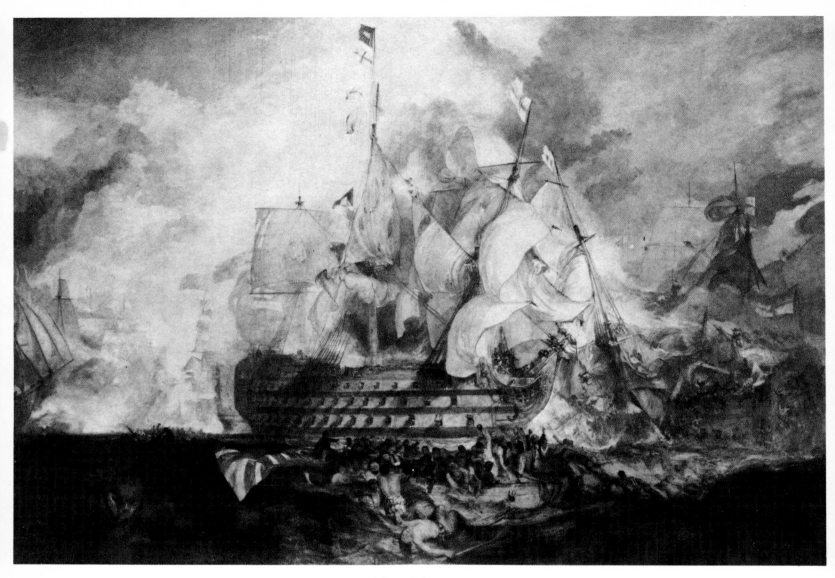

5. *The Battle of Trafalgar.* 1823. Oil on canvas, 8′7″ x 12′1″ (261.6 x 368.3 cm.). National Maritime Museum, London

LIFE

Joseph Mallord William Turner was a short, stocky man with rather striking features, who, without advantage of education or birth, became through genius, determination, and boundless energy the greatest artist England has ever known. Neither heredity nor environment explains his talent for art. He was born in London on April 23, 1775, the son of a barber. The family lived in Maiden Lane, Covent Garden, a fashionable quarter for hairdressers and wigmakers. Because of an illness, perhaps his, perhaps his sister's, his family sent him to stay with his mother's brother, a butcher who lived in Brentford, near London. It was on this visit that Turner, aged about ten, saw the country for the first time. He explored Twickenham and inspected its handsome villas; from there he looked across the river at Hampton Court, with its beautiful lawns and trees, and watched the barges being pulled slowly and with difficulty up the Thames.

How long Turner remained at Brentford is uncertain, but when he returned to London he must have spent much of his time among the warehouses and docks of the busiest harbor in the world, gazing on, to quote Ruskin, "that mysterious forest below London bridge, better for the boy than wood of pine, or grove of myrtle. How long he must have tormented the watermen, beseeching them to let him crouch anywhere in the bows, quiet as a log, so that only he might get floated down there among the ships, and round and round the ships, and by the ships, and under the ships, staring and clambering; —these the only quite beautiful things he can see in all the world, except the sky; but these, when the sun is on their sails, filling or falling, endlessly disordered by sway of tide and stress of anchorage, beautiful unspeakably; which ships also are inhabited by glorious creatures—redfaced sailors with pipes, appearing over the gunwales, true knights, over their castle parapets."[15]

Such sights of England's naval power and merchant marine,

glimpses of the ships that dominated all the seas of the earth, made an indelible impression on Turner's mind, preparing him for the revelation of a "green mezzotinto, a Vandervelde—an upright; a single large vessel running before the wind and bearing up bravely against the waves," which, with some emotion, he told his close friend the Reverend H. S. Trimmer, "made me a painter."[16] But his earliest pictures had nothing to do with the sea. According to Walter Thornbury, Turner's talent first became evident in his boyhood when he began drawing cocks and hens with a piece of chalk as he walked to his school in Brentford. During this period he is said to have colored some of the plates in Henry Boswell's *Picturesque Views of the Antiquities of England and Wales* at two pence a plate, and he also put in backgrounds to architects' renderings.[17] The earliest drawing preserved, however, is a copy of an engraving of Oxford, done when he was twelve. He must have been pleased with it, for he kept it all his life. For some time he continued to copy and adapt the engravings of others. At fourteen he made what were probably his first studies from nature. By this time his work had reached sufficient volume for the barber to hang up his son's drawings in his shop window for sale at prices varying from one to three shillings.

We know little about Turner's education as an artist. At the age of fourteen, he studied with Thomas Malton, an able teacher. There were also the evenings spent several years later with Dr. Thomas Monro, a well-known collector. The doctor owned many watercolors by John Robert Cozens; and Turner and Thomas Girtin, both born the same year, were, according to tradition, employed for a time to copy them. But the question arises: why would a collector want his collection duplicated? Finberg, after considerable research, concluded that the two young men were occupied making finished watercolors from Cozens's unfinished drawings.[18] Girtin apparently drew the outlines and Turner applied the washes. Doubtless both youthful geniuses learned a good deal technically from these routine exercises. But the real benefit of their close study of Cozens was the knowledge they gained of a great artist's reaction to natural beauty. They came to understand his passionate response and ultimately learned to convey their own equally ardent feelings.

The painter Edward Dayes, who seems himself to have had considerable influence on Turner's work, says in his biographical sketch of the artist, written sometime before 1804, that "He [Turner] may be considered as a striking instance of how much may be gained by industry, if accompanied with temperance, even without the assistance of a master. The way he acquired his professional powers was by borrowing, where he could, a drawing or picture to copy from; or by making a sketch of any one in the Exhibition early in the morning, and finishing it at home."[19]

Dayes has summarized two important aspects of Turner's artistic education. He ignores, however, the artist's work from 1789-93 at the Royal Academy Schools, where he drew fairly regularly from the antique and also from life. But copying the work of others and sketching from nature were the main methods by which Turner taught himself. When he was only eighteen, his wayfaring began, his tireless search for picturesque subjects for his watercolors and drawings. He

6. *Crypt of Kirkstall Abbey,* 1797.
Pencil and wash, 7⅞ x 10⅝" (19.7 x 27 cm.).
British Museum, London

traveled widely in England and Wales, sketching mountains, lakes, ruins, famous buildings, a type of work immensely popular. Throughout his life topographical painting was to provide a major source of income. He soon had a ready market among collectors, but his profits were small, for his prices were modest. Engravers also became eager to use his drawings. In 1790 he had a watercolor exhibited at the Academy and was praised by the critics. He had started on a successful career which even the bitter attacks which were later made on his work would not permanently affect.

We have a description of Turner at about this time written many years later for Ruskin by Ann Dart, a niece of John Narraway, with whom the painter stayed for some time. Narraway was a friend of Turner's father. Turner, Miss Dart wrote, was "not like young people in general, he was singular and very silent, seemed exclusively devoted to his drawing, would not go into society, did not like 'plays,' and though my uncles and cousins were very fond of music, he would take no part, and had for music no talent." Then she makes a very significant comment about a self-portrait Turner painted in watercolor, which Ruskin had bought from her and which is now in the London National Portrait Gallery. The artist, when asked by the Narraways to do the portrait, "said 'it's no use taking such a little figure as mine, it will do my drawings an injury, people will say such a little fellow as this can never draw.' "[20] Turner seems to have been sensitive about his height. As Dayes wrote, "The man must be loved for his works, for his person is not striking nor his conversation brilliant."[21] And this Turner himself recognized. Miss Dart sums up by saying that Turner "would talk of nothing but his drawings and of the places he would go for sketching. He seemed an uneducated youth, desirous of nothing but improvement in his art."[22]

Hiking was Turner's hobby and was also an essential part of his work. He became inured to the simple fare and hard beds of English inns. With his baggage tied up in a handkerchief on the end of a stick, he would walk twenty-five miles a day,

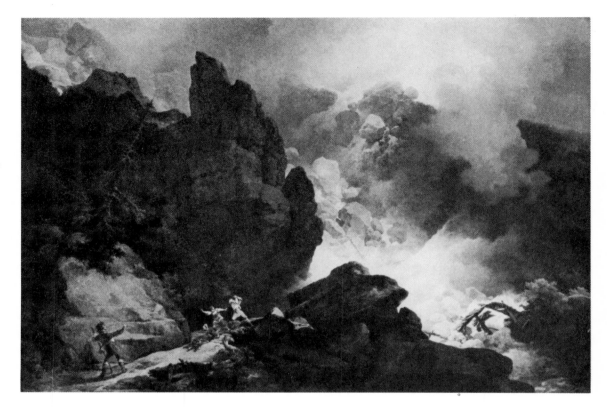

7. Philip de Loutherbourg.
An Avalanche in the Alps. c. 1803.
Oil on canvas, 43¼ x 63″
(109.9 x 160 cm.).
Tate Gallery, London

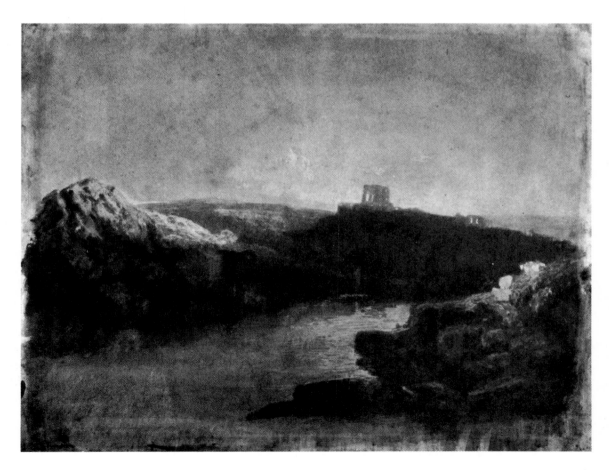

8. *Norham Castle.* 1798.
Pencil and watercolor,
26⅛ x 33⅛″(66.4 x 84.1 cm.).
British Museum, London

tramping through the countryside in search of subject matter for his drawings. When these were made, he would return to London and turn his pencil sketches into watercolors.

In 1796, when he was twenty-one, Turner sent ten watercolors to the annual exhibition at the Royal Academy, the most important of these being the interiors of Ely Cathedral (fig. 38) and Westminster Abbey. These pictures show that he had attained an absolute mastery of light and shade, of perspective, of architectural detail. There is a sureness in every touch that he was never to surpass. In the same exhibition, it is generally believed, he showed his first oil painting, *Fishermen at Sea* (colorplate 1). A contemporary critic called it "one of the greatest proofs of an original mind in the present display."[23]

Two years later Turner told a fellow artist, the Royal Academician Joseph Farington, that he had more commissions than he could execute and got more money than he could spend. He wondered whether he should place himself in a more respectable situation. Farington advised the artist not to move from his parents' home for the present. But later the diarist mentions that he "called on him at his Father's, a Hair Dresser, in Hand-Court, Maiden Lane—The apartment to be sure small and ill calculated for a painter."[24] However, Farington does not say whether he changed his counsel.

To advise Turner to stay with his parents was a mistake. Not only was he "cabin'd, cribb'd, confined" in his narrow quarters, but the atmosphere in his home must have driven him to distraction. His mother was subject to appalling tantrums, which became so violent that she finally had to be sent to an asylum. She was a lifelong burden to her son, who resented any reference to her; and doubtless the misery of his parents' marriage affected him profoundly. After his mother was hospitalized, however, his father became a close companion, and the two lived together until the elder Turner's death in his eighty-fifth year. After a time their roles were reversed, and Turner looked on his father as a son, caring for him with the greatest tenderness.

Even if Turner's home life was far from happy, his artistic career was flourishing. His works exhibited at the Royal Academy were admired, and he was beginning to be generally known as the most promising of the younger artists. The painter John Hoppner was one of those who praised him highly. In 1798 Hoppner visited Turner's studio to see what he had in preparation for the next Academy exhibition. On that occasion, however, Hoppner was disappointed, and the judgment he passed on to Farington now seems as wide of the mark as possible. He found Turner "a timid man, afraid to venture"[25]—this about one of the most innovative and revolutionary painters who ever lived!

But Turner was not too diffident to stand for election that year as an Associate of the Royal Academy. Though he was only twenty-three, and a recently passed bylaw specified that candidates had to be twenty-four or more, Farington, the most politically-minded of the Academicians, encouraged him to believe he would be elected. But he came in third in the competition for the two vacancies. In 1799 he stood again and was successful, the only Associate chosen that year.

It must have been about this time that Turner's liaison with the singer and actress Sarah Danby began. Mrs. Danby's husband, a composer of glees, had died in 1798, the year Turner failed to be chosen an Associate of the Academy. The young widow seems to have fallen in love with the painter and to have become his mistress. They never married. It is possible that Turner's parents' unhappiness made him unwilling to consider matrimony, but he was far from being a misogynist. He admired women immensely and once scribbled in a sketchbook, "There is not a quality or endowment, faculty or ability, which is not in a superior degree possesst [sic] by women."[26] Sarah Danby had several children by her husband, but her last two daughters were probably Turner's. He was not, however, greatly interested in his human progeny. His real children were his paintings. Once when a close friend asked him why he was looking so melancholy, he replied, "I have been sending some of my *children* away today."[27] It saddened him to part with a favorite picture, and he hoped that after his death all his pictorial "children" which remained in his possession would be permanently kept together.

Since Turner's work required larger and better-lighted rooms, he finally left his parents' house, moving with his father to 64 Harley Street in January 1800. There his apprehensions about matrimony may have been reinforced by a fellow lodger, the marine painter J. T. Serres. Serres's wife developed delusions that she was the daughter of the Duke of Cumberland. Her financial extravagances ruined Serres. Sarah Danby was living nearby in Upper St. John Street, and doubtless Turner was pleased that he could visit her yet remain a bachelor.

He was, as always, preoccupied with his career. The next step was to change from associate to full membership in the Academy. Farington, the political busybody among the Academicians, tells how Turner in 1802 again canvassed for his election. He paid court to the members who were undecided, like Philip de Loutherbourg and J. J. Russell. These he won over with words, but he was not above giving an occasional drawing or watercolor to assure the support of others. When all the Royal Academicians (except Angelica Kauffmann, who was in Rome) assembled for the voting, Turner's campaign among them proved to have been so successful that he was easily elected. Nevertheless, it was as well he recognized that election to that august body was not always based solely on merit.

Turner's early work has been well characterized by Finberg. Its qualities are "intelligence, docility, alertness, indomitable industry, patience, and great dexterity of eye and hand.... His triumphs are the triumphs of the commonplace virtues— intelligence and industry—working upon a foundation of natural talent, rather than of what is generally understood as genius."[28]

The spark of genius, however, lay dormant. It blazed up when, in the spring of 1799, Turner saw the two "Altieri" paintings by Claude Lorrain. These had just been bought by the influential collector William Beckford and were on display in his house in Grosvenor Square. On seeing Claude's *Sacrifice to Apollo* (1663), Turner exclaimed, according to Farington, that "it seemed to be beyond the power of imitation."[29] The next year he painted his first historical picture, *The Fifth Plague of Egypt* (fig. 9), which was the largest canvas he had executed. Historical painting was then regarded as the highest

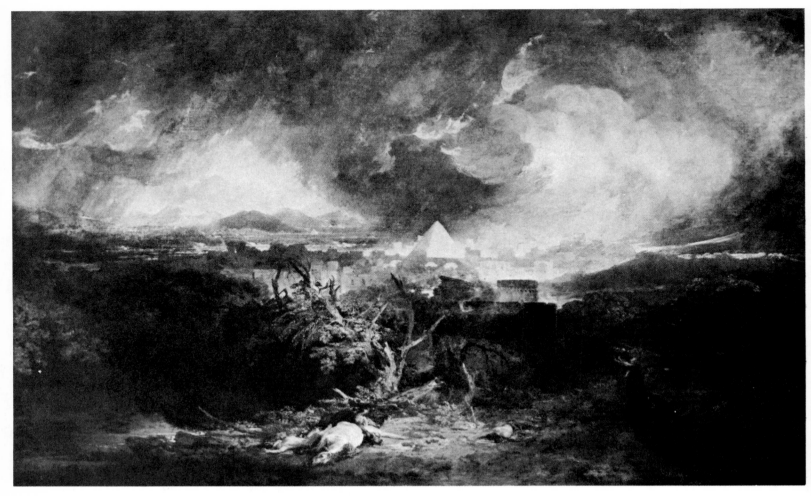

9. *The Fifth Plague of Egypt.* 1800. Oil on canvas, 49 x 72″ (124.5 x 183 cm.).
Indianapolis Museum of Art. Gift in memory of Evan F. Lilly

branch of art, and the critics approved the altered direction of Turner's work, saying that this gave him ''a new character in his profession.''[30] Beckford, perhaps realizing what his paintings by Claude had done for Turner, bought the picture for 150 guineas.[31]

In the three years between becoming an Associate of the Royal Academy and being elected to full membership in 1802, Turner's style continued to change. But as his genius began to shine, there were critics who began to cavil. *Fishermen Upon a Lee-Shore* (fig. 10), exhibited the year he became a Royal Academician, was considered ''much too indeterminate and wild.''[32] His *Tenth Plague of Egypt* (colorplate 3), unlike the *Fifth Plague,* found no buyer. Farington sums up the general opinion of Turner's work when he writes in his diary, ''Turner strives for singularity and the sublime but has not strength to perform what he undertakes. His pictures have much merit, but want the scientific knowledge and the Academick truth of Poussin, when he attempts the highest style, and in his shipping scenes he has not the taste and dexterity of pencilling which are found in such excellence in the Dutch and Flemish masters.''[33]

Did Farington convey these sentiments to the younger

Academician, one hopes with more tact? We do not know, but in 1802, as soon as the Peace of Amiens was signed, temporarily ending the war between England and France, Turner departed for the Continent, principally to study Poussin and other Old Masters in the Louvre. But first, after only a brief stop in Paris, he went on to see the mountains of Switzerland, which were to provide the inspiration for many of his finest works. Farington relates that Turner found ''the lines of the landscape features [of the Alps] rather broken but there are many fine parts,—fragments and precipices very romantic and strikingly grand.'' The houses were ''bad forms—tiles abominable red colour.'' Still, ''the Country on the whole surpasses Wales; and Scotland too. The weather was very fine. He saw very fine Thunderstorms among the Mountains.''[34]

When Turner returned to Paris in September, he spent many hours in the Louvre. His sketchbook, labeled ''Studies in the Louvre,'' has been preserved in the British Museum. There are over twenty rough sketches of paintings drawn in pencil with scratched highlights, several of which he colored, and about thirty pages of notes.[35] Of the many masterpieces he saw, those of Titian were the greatest revelation. He wrote about and made drawings after *The Entombment, The*

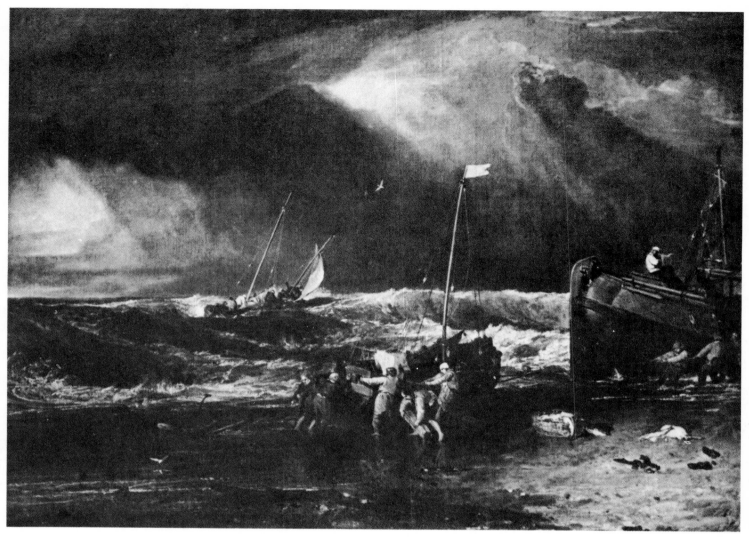

10. *Fishermen Upon a Lee-Shore.* 1802. Oil on canvas, 36 x 48″ (91.5 x 122 cm.).
Greater London Council as Trustee of the Iveagh Bequest, Kenwood

Crowning with Thorns, and *Alfonso d'Este and Laura Dianti*; and he devoted two pages of text to *St. Peter Martyr,* remarking that ''This picture is an instance of his great power as to conception and sublimity of intellect. The characters are finely contrasted, the composition is beyond all system, the landscape the' natural is heroic, the figures wonderfully expressive of surprise and its concomitant fear.'' Of Poussin, the other artist to whom he devotes great attention, he was more critical. He thought Poussin's paintings in the collections of the Duke of Bridgewater and Lord Ashburnham finer than those in the Louvre. Among the Louvre canvases he considered the *Gathering of Manna* the best; in many of the others he felt the colors had ''been heightened'' by repainting. He was very critical of *The Deluge.* ''The lines are defective as to conception of a swamp'd world...the boat on the waterfall is ill-judged.''

Among the Dutch painters he commented only on Rembrandt and Jacob van Ruisdael. Rembrandt disappointed him, but of Ruisdael's *Coup de Soleil* he wrote, ''A fine coloured grey picture, full of truth and finely treated as to light which falls on the middle ground...the sky rather heavy, but well managed, but usurps too much of the picture and the light.''

He had no patience with Rubens's exuberance, and he does not mention Claude at all, though on another trip in 1821 he sketched a number of the latter's canvases. In 1802 he had learned from the Altieri pictures perhaps everything that Claude could teach him. These days spent in the Louvre had a profound effect on Turner's whole concept of art. He returned to England more confident and still more determined.

For a time he immured himself in his studio, partly to continue his interrupted work and partly to assimilate what he had learned abroad. But he also began to show that interest in the affairs of the Royal Academy which was to remain with him throughout his life.

Established by George III in 1768, the Royal Academy was limited to a membership of forty and was governed by an elected council of eight, four of whom retired annually. The king provided the premises, at first a former print warehouse on the south side of Pall Mall, and in 1780 certain of the apartments of Somerset House on the Strand. The prerogatives of the royal founder, however, were ill-defined, and no royal authority was exercised until 1799. That year Henry Tresham, an Irish artist, complained that the regulations governing election to the council had been infringed because he had not been voted to a

seat the year after he became an Academician. Sir William Beechey, a fellow Academician and the queen's portrait painter, carried the complaint to the king, who supported Tresham and decreed that henceforth membership on the council should be by rotation and not by election. After this incident, a faction appeared which wished to make the Academy more dependent on the king.

When Turner became a member of the council in 1803, he at once found himself in a power struggle between the two factions, the "Court Party" and the "Democrats." The Court Party on the council, when Turner joined it, consisted of James Wyatt, John Singleton Copley, Sir Peter Francis Bourgeois, and John Yenn. On the other side were Ozias Humphry, Sir John Soane, John Charles Felix Rossi, and Turner. Humphry was absent from many meetings, and Soane went over to the royalists. Thus having become the majority, the royalists passed a resolution placing power in the hands of the council, which they controlled, and diminishing the power of the General Assembly (which comprised all forty Academicians), where they were in the minority. Bickering of exceptional bitterness followed, acerbated by Copley's leak to the press that Benjamin West was about to show a picture he had previously exhibited, a practice contrary to the rules of the Academy. There were arguments over expunging minutes of the council, indignation over the omission of the architectural prize, fights over the election of a keeper, and such general acrimony that it seemed as though the Academy might fall apart.

Perhaps for this reason, Turner in 1804 decided to establish his own gallery. He extended the first floor of his house at 64 Harley Street, creating a room seventy feet long and twenty feet wide which would accommodate about twenty or thirty large canvases, as paintings were then hung. This caused a mistaken rumor that he was no longer going to exhibit at the Academy. On the contrary, during the fifty-eight years of his activity as a painter, he failed to show at the Academy only four times: in 1815, 1821, 1824, and 1851. As Jack Lindsay has perspicaciously noted, to Turner "the Academy had become a maternal protecting figure under whose aegis,

despite all the back-biting and intrigues, he had been able to consolidate his position and achieve independence. So, after the period of disillusioning struggle, he returned to an acceptance of it as a sort of necessary evil modified by many useful functions. He did not drop his independent activities, but saw them as ancillary, as an insurance against further disruptions or breakdowns of the institution."[36]

Lindsay's astute conjecture is based on an anecdote told by Walter Thornbury, who recounts that "The day wrongheaded Haydon ended his untoward life, Mr. [Daniel] Maclise [the British painter] called upon Turner to tell him of the horrible catastrophe.... To his astonishment Turner scarcely stopped painting, and merely growled out between his teeth 'He stabbed his mother, he stabbed his mother.'"[37] It was only later that Maclise realized that the stabs Turner had in mind were not attacks on a human being. He was thinking of Benjamin Robert Haydon's attacks on the Academy. To Turner the Academy was the mother of all the best British painters, and in assailing this revered institution Haydon was guilty of attempting matricide.

In 1807 Turner was elected Professor of Perspective at the Academy by a vote of twenty-seven to one, an indication of the esteem in which he was held. No salary was attached to the office, but he was paid a fee for each lecture he gave. He was dilatory about delivering his first discourse, waiting four years before he spoke. When he finally mounted the rostrum of the Academy, his delivery continued the tradition of inaudibility begun by Sir Joshua Reynolds, but his prose fell far below the grammatical standards of the first president. He did, however, prepare nearly two hundred large drawings and diagrams to illustrate his points, and these, as his fellow artist Richard Redgrave said, spoke "intelligibly enough to the eye, if his language did not to the ear."[38]

Turner retained the title of Professor of Perspective, which he greatly valued, until December 1837, when, at the age of sixty-two, he announced his intended retirement. According to the official minutes it was noted with regret. To quote Finberg, "It must, however, have been received with some satisfaction, for the obstinacy with which he had retained this office

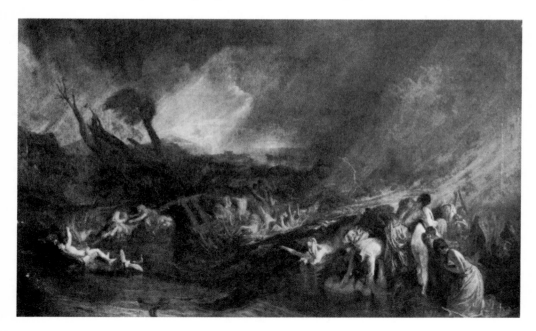

11. *The Destruction of Sodom (The Deluge).* c. 1804. Oil on canvas, 57 x 93" (144.8 x 236.2 cm.). Tate Gallery, London

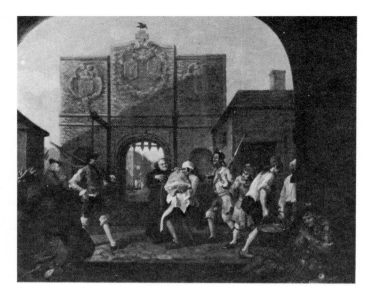

12. William Hogarth.
O the Roast Beef of Old England!
('Calais Gate'). 1748.
Oil on canvas, 31 x 37¼"
(78.7 x 94.6 cm.).
Tate Gallery, London

13. John Constable. *Wivenhoe Park, Essex.* 1816.
Oil on canvas, 22⅛ x 39⅞" (56.2 x 101.3 cm.).
National Gallery of Art, Washington, D.C.
The Widener Collection

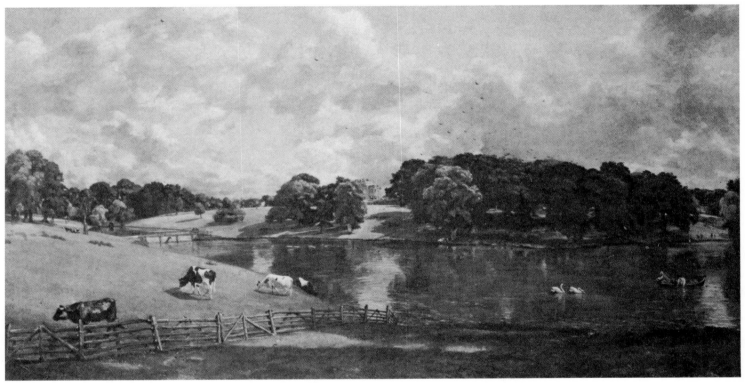

without delivering the prescribed course of lectures had been a constant source of embarrassment to his colleagues."[39]

Turner's relations with the other Academicians are puzzling. He was certainly admired, but from the time of the exhibition of 1803, at which he showed *Festival at Macon, Holy Family,* and *Calais Pier* (colorplate 4; compare Hogarth's *Calais Gate,* fig. 12), he was unceasingly criticized. He had now departed too far, they thought, from their standards of the imitation of nature. John Hoppner summarized their opinions when he said that "so much was left to be imagined that it was like looking into a coal fire, or upon an Old Wall, where from many varying and undefined forms the fancy was to be employed in conceiving things." James Northcote found too little of nature, too much of novelty. Henry Fuseli thought the fore-

grounds of *Calais Pier* and *Festival at Macon* "too little attended to—too undefined." Others were even more critical.[40]

Turner's progress was met with what now seems astonishing hostility. His most persistent enemy was Sir George Beaumont, a well-to-do baronet who was among the first benefactors of the British National Gallery and who was considered by the world of fashion an outstanding landscapist. Beaumont's colleagues, however, with the exception of John Constable, judged him mediocre, a poor imitator of his heroes Poussin and Claude. Nevertheless, Sir George's opinion had considerable influence. Farington reports that in 1806, when Turner showed at the newly established British Institution, Beaumont told him that Turner's paintings "appeared to him to be the work of an *old man* who had ideas but had lost the

power of execution."[41] And a few months later Farington records that he held a conversation with Beaumont and others "on the vicious practise of Turner and his followers."[42] As Finberg says, "What roused Farington and his friends even more than Turner's artistic vices was the large prices he obtained for his works and the number of young artists who admired and attempted to imitate him."[43] But it is also true that Turner's critics could not understand his search for the sublime in nature, his continuing endeavor to reach new limits in the painting of landscape.

If Turner was hurt by this criticism, he hid his wounds. Throughout his life he attempted to conceal his natural melancholy and bitterness with gaiety, as he did, for example, during a long visit to his friend W. F. Wells at Knockholt in Kent in the latter part of 1806. Wells's daughter, Clara Wheeler, records, "Of all the light-hearted, merry creatures I ever knew Turner was the most so; and the laughter and fun that abounded when he was an inmate of our cottage was inconceivable."[44]

W. F. Wells was a teacher of drawing and the president of the Watercolour Society, which he had founded. Turner, always cautious and suspicious, trusted him as he did few others. It was Wells who proposed that Turner should draw in pen with sepia washes a series of pictures illustrating various types of landscape composition and should then have these mezzotinted under his own supervision, the whole to be called the *Liber Studiorum.* In 1777 Richard Earlom and Josiah Boydell had brought out the *Liber Veritatis,* a book of drawings Claude had done to authenticate his paintings. But Turner's objective was different. His drawings were not made to verify his pictures, since no one at that time was forging them. Instead, the prints were to fulfill a triple purpose: to show the range and variety of his genius; to disseminate his work and help to ensure his reputation with posterity; and to be profitable, as his other engravings had proved to be, if not always to the publisher, at least to himself. But a risk was involved, capital was required, and the unprecedented enterprise must have seemed at first too bold.

Wells, however, continued to press until finally, according to Mrs. Wheeler, Turner said, grumbling, "Zounds, Gaffer, there will be no peace with you till I begin...well, give me a sheet of paper there, rule the size for me, tell me what subject I shall take."[45] The first number of this tremendous undertaking, a project never finished but which was intended to comprise a hundred plates, was shown in Turner's gallery in June 1807.

That same spring Benjamin West visited the gallery, and, according to Farington, was "disgusted at what he found there; 'views on the Thames, crude blotches, nothing could be more vicious.'"[46] Turner was well aware of his colleagues' disapproval. The two pictures he showed that summer at the Academy, *Sun Rising Through Vapour* (colorplate 7) and *The Blacksmith's Shop* (colorplate 6), were perhaps intended to appease such criticism. *The Blacksmith's Shop* in particular marked a temporary rest in his search for the sublime, and was also a challenge to such popular genre painters as David Wilkie. Turner frequently reverted to an earlier way of feeling, as though he needed relief from his passionate search for the limits of painting. Also, there is no doubt that he wanted an

14. Liber Studiorum: *The Fifth Plague of Egypt.* Published 1808. Etching and mezzotint, 7⅛ x 10¼" (18 x 25.9 cm.). British Museum, London [Engraved by Charles Turner]

occasional favorable comment in the press, and, above all, further sales, something never absent from his mind.

Considering the amount of money he took in, he must have sold a great many paintings, but even so, how he accumulated the £140,000 mentioned in connection with his will has never been satisfactorily explained. Many of his paintings exhibited at the Royal Academy and the British Institution did not find purchasers, although in his own gallery he apparently was more successful. There he showed many oils, watercolors, and drawings he did not exhibit elsewhere. In 1808, George Wyndham, the third earl of Egremont, bought four pictures from the gallery, and we know of three others that were sold that year, none of which had been previously exhibited. The total sales for these works amounted to £1,417 10d. and if we take this as representative of the greater part of a given year's income, it would take almost a century, assuming no expenses of any kind, to save £140,000 in cash.[47] To illustrate this, by 1810 his account in the Funds had reached only a little over £7,000.[48]

There is, however, a partial explanation for the great wealth attributed to a painter who was generally successful but certainly not popular. It is that this large sum has been accepted by biographers at its face value, based on a statement made at the end of Turner's probated will: "Effects sworn under 140,000 pounds." However, the value placed on the pictures remaining in his studio must have accounted for a large part of these assets. In actual cash the estate was probably much smaller.

In 1810, Turner, thirty-five years old and at the height of his productivity, determined to take stock of what he possessed. He owned some land in Richmond and had bought a house on Queen Ann Street West, around the corner from his house on Harley Street; he intended to build a second gallery in the new house. He had a number of unsold pictures, which had some value, though he concluded that they had missed their market. His books and furniture he valued at £300, and

15. David Wilkie. *The Blind Fiddler.* 1806.
Oil on wood, 23 x 31″ (58.4 x 78.7 cm.).
Tate Gallery, London

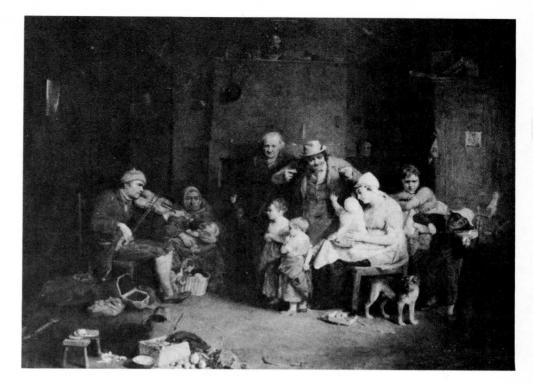

16. *Windsor Castle from the Thames.* c. 1804–5.
Oil on canvas, 35 x 47″ (89 x 119.5 cm.).
The National Trust.
From the Petworth Collection,
Sussex, England

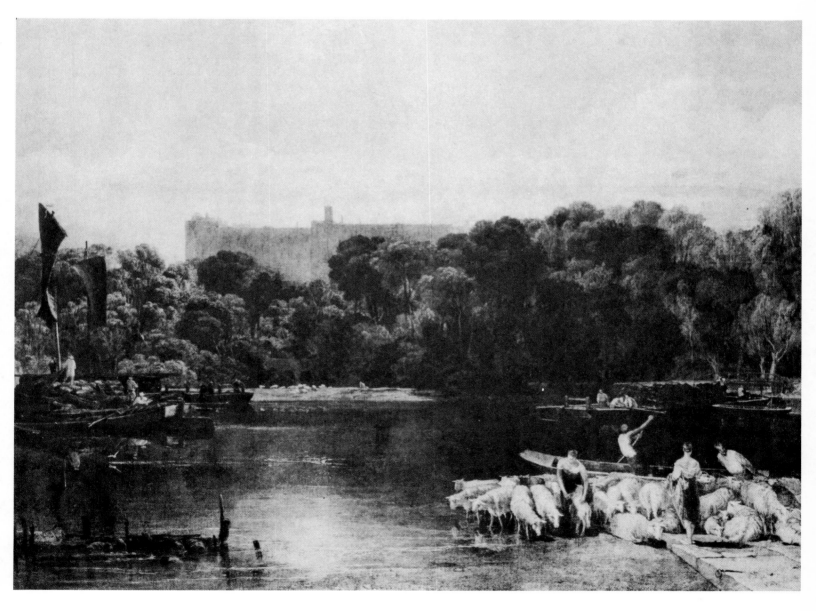

17. *Academy Study of a Female Nude.* 1809–10.
Pencil and watercolor, 3¼ x 4½" (8.3 x 11.5 cm.).
British Museum, London

he expected to earn £2,000 from his *Liber Studiorum* (this turned out to be an overly optimistic figure). He concluded that he was worth between £12,000 and £13,000. He felt justified in spending £1,200 on his house on Queen Ann Street and £500 to begin construction of a country house in Twickenham.[49]

It is as well that he had saved as much as he had. Sir George Beaumont's unceasing attacks were bearing fruit, and he intensified his vendetta. Turner's success was a direct challenge to Beaumont's reputation as a connoisseur. Augustus Callcott, always looked on as Turner's closest follower, in 1813 complained to Farington "that he had not sold a picture in the Exhibition in the last three years or received a commission arising from it. He said Sir George Beaumont's persevering abuse of his pictures had done him much harm . . . that Turner suffered from the same cause, and had not sold a picture for some time past. Turner called upon Callcott at Kensington a while since and then said he did not mean to exhibit from the same cause that prevented Callcott, but he has since altered his mind and determined not to give way before Sir George's remarks."[50]

Farington had heard from the other camp in 1812 when he stayed with the Beaumonts at their country house. Sir George said that "Turner had done more harm in misleading the taste than any other artist. At the setting out he painted some pictures,. *The Plagues of Egypt,* which gave great promise of his becoming an artist of high eminence, but that he had fallen into a manner that was neither true or consistent. . . . Much harm, added he, has been done by endeavouring to make paintings in oil to appear like watercolours, by which, in attempting to give lightness and clearness, the force of oil painting is lost."[51]

There is some truth in Sir George's observations. From his work in watercolor Turner had learned that washes over white paper convey a luminosity wanting in traditional oil painting. More and more he rejected the brown and black tones he had

originally employed. Unlike previous landscapists, he worked on a light ground and painted in a higher key than had ever been used. He and his followers came to be known as "The White Painters," an innocent enough classification, but at the time applied venomously.

During this period Turner moved with his father to his house in Twickenham (see fig. 18), which later became known as Sandycombe Lodge. The Reverend H. S. Trimmer, a friend of the artist, described the simplicity of their life to Thornbury: "Everything was of the most modest pretensions, two-pronged forks, and knives with large round ends for taking up the food . . . the table cloth barely covered the table, the earthenware was in strict keeping."[52]

They were a close corporation, the two Turners. The father prepared his son's canvases and applied the final varnishes. Turner used to say his father "began and finished" his pictures for him. "Old Dad," as he called him, also looked after the gallery in Queen Ann Street. Yet in spite of all their economies, expenses increased, and lack of sales made the Turners uneasy. Thornbury says that one day a friend saw "Old Dad," "gay, happy, and jumping up on his old toes. 'Why lookee here,' he said, 'I have found a way at last of coming up cheap from Twickenham to open my son's gallery. I found out the inn where the market gardners baited their horses. I made friends with one ... and now for a glass of gin a day, he brings me up in his cart on top of the vegetables.' "[53] But sometimes, even at sixty-eight, the elder Turner walked the eleven miles rather than pay a trifling fare.

Though sales of paintings may have declined under the buffeting Beaumont was giving Turner's reputation, by July 1813 the artist's investment in the Funds was £2,000 higher than in 1810.[54] He had completed his cottage in Twickenham and had enlarged and renovated his house in Queen Ann Street. Turner had found a way of circumventing Sir George Beaumont's malice. He was devoting much of his time to topographical work for the engravers. He recognized that engravings after his drawings and watercolors did not lend themselves to attack. He could transcribe more brilliantly than any of his competitors whatever scene or building took his fancy; and his critics, confronted with the print in black and white, could not complain, as they so frequently did, of his

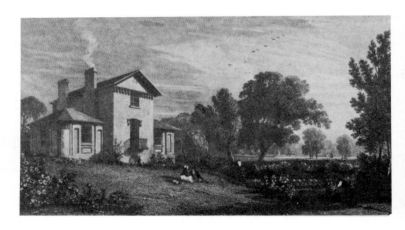

18. W. B. Cooke, after W. Havell. *Sandycombe Lodge.* 1814.
Engraving, 4⅜ x 7⅞" (11.2 x 19.9 cm.).
From *Picturesque Views on the River Thames.*
Victoria and Albert Museum, London

19. *Frosty Morning.* 1813. Oil on canvas, 44½ x 68½″ (113.5 x 174.5 cm.). Tate Gallery, London

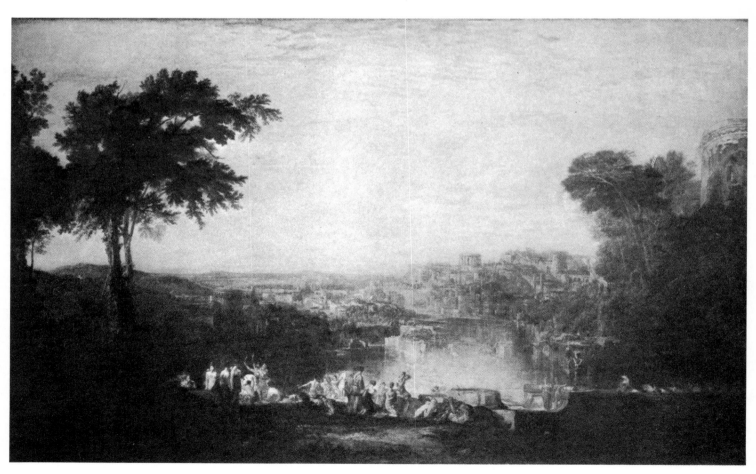

20. *Dido and Aeneas Leaving Carthage on the Morning of the Chase.* 1814.
Oil on canvas, 58 x 95″ (147.3 x 241.3 cm.). Tate Gallery, London

coloring. Nor were his foregrounds so abstract as to arouse their hostility. His prints sold well, and publishers were eager to reproduce his work.

But even though printmaking produced a sizable income for Turner it doubtless provided less than he made from the sale of his watercolors. A few passionate collectors like Walter Fawkes, who owned over two hundred, must have been responsible for much of his wealth. These watercolors, however, were not what Turner valued most. His "children," as he called them, were his oils. He was acutely sensitive to the harsh criticism his canvases received when they were shown at the Royal Academy. Reverend Trimmer told Thornbury that "no one felt more keenly the illiberal strictures of the newspapers, and I have seen him almost in tears, and ready to hang himself, though still only rating their opinions at their worth."[55] Turner was never critical of other artists. He knew the difficulties of his profession. He was always ready to give helpful advice and encouragement. As for

censure, to quote Ruskin's remarks to Thornbury, "Owing to his own natural kindness, he felt it for himself or for others, not as criticism, but as cruelty. He knew that however little his higher power could be seen, he had at least done as much as ought to have saved him from wanton insult, and the attacks upon him in his later years were to him not merely contemptible in their ignorance, but amazing in their ingratitude."[56]

It was such an attack that brought John Ruskin at the age of seventeen to Turner's defense. At the Academy Exhibition of 1836 Turner showed *Juliet and Her Nurse* (colorplate 30). Years later Ruskin wrote in his autobiography: "His [Turner's] freak in placing Juliet at Venice instead of Verona, and the mysteries of lamplight and rockets with which he had disguised Venice herself, gave occasion to an article in *Blackwood's Magazine* of sufficiently telling ribaldry, expressing, with some force, and extreme discourtesy, the feelings of the pupils of Sir George Beaumont at the appearance of these unac-

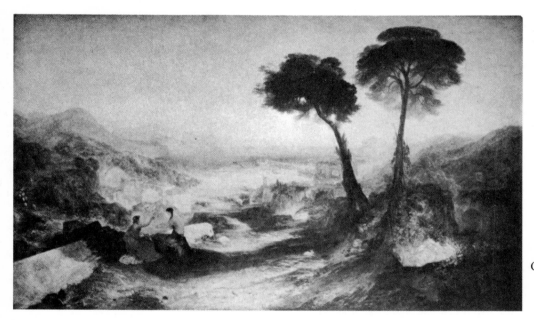

21. *The Bay of Baiae,*
with Apollo and the Sibyl. c. 1823.
Oil on canvas, 57½ x 93½" (146 x 239 cm.).
Tate Gallery, London

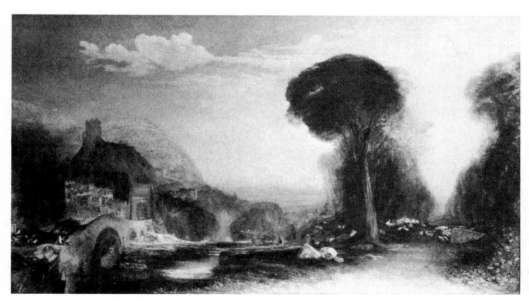

22. *Palestrina.* 1830.
Oil on canvas, 55½ x 98" (141 x 249 cm.).
Tate Gallery, London

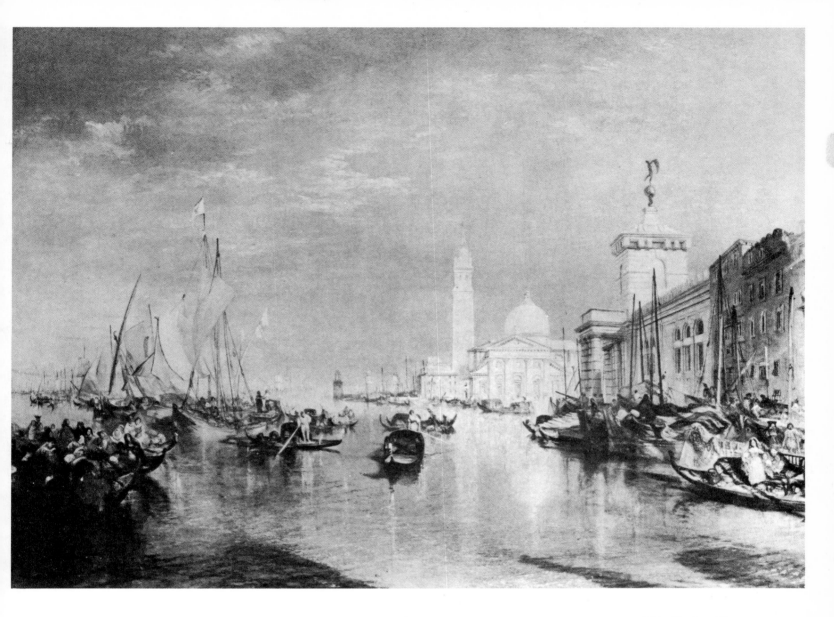

23. *Venice: The Dogana
and San Giorgio Maggiore.* 1834.
Oil on canvas, 36 x 48″ (91.5 x 122 cm.).
National Gallery of Art,
Washington, D.C.
The Widener Collection

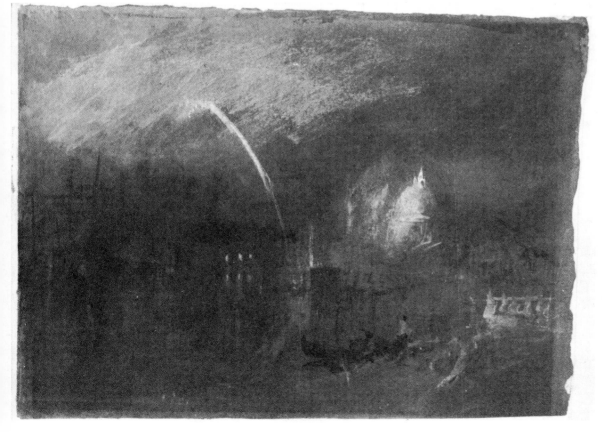

24. *Santa Maria della Salute
and the Dogana, Venice—
Night Scene with Rockets.* 1835.
Watercolor and gouache on brown paper,
9½ x 12⅜″ (21 x 34.5 cm.).
British Museum, London

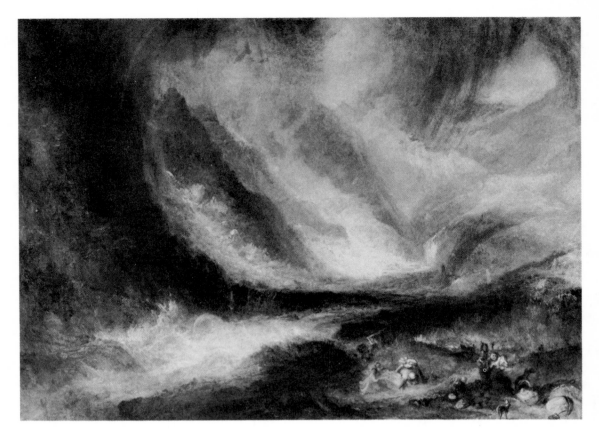

25. *Valley of Aosta—Snow Storm, Avalanche, and Thunderstorm.* 1836-37. Oil on canvas, 36¼ x 48" (92 x 122 cm.). The Art Institute of Chicago. Frederick T. Haskell Collection

credited views of Nature. The review raised me to the height of black anger in which I have remained pretty nearly ever since; and having by that time some confidence in my power of words...I wrote an answer to *Blackwood's,* of which I wish I could now find any fragment.''[57] The criticism in *Blackwood's* actually was not worth answering, and Turner persuaded the young Ruskin to withhold his letter; but one might go so far as to say that Juliet and her nurse were placed in Venice by poetic license because Turner had come to love that city above all others.

Turner first visited Venice in 1819 during his initial trip to Italy. The trip was a turning point in his life. At the age of forty-four he found the light he had always sought, the dazzling orange sunlight of the Mediterranean, its warmth a foil to the blue of the sky and the azure of the tranquil sea. This brilliance was a counterpart to the grayish light of England, which gleamed through broken clouds, falling on drenched meadows and stormy, forbidding seas. He mastered both types of illumination, but in his later paintings he preferred the glow of the southern sun. In Italy he sketched Rome, the Campagna, Vesuvius, the Bay of Naples, and above all Venice, making on this first journey some 1,500 drawings in black and white.[58] These drawings were his memoranda, later serving as the bases for his canvases. He made other trips to the Classical world and the Venetian lagoons—major ones in 1828, 1835, and 1840—continually supplementing his sketches. But the light and color of Italy he carried only in his mind's eye Working from his sketches and drawing on his extraordinary

visual memory, he painted what he had seen and what he had imagined on these seminal journeys.

Ruskin too loved Italy, and Turner's work was his guide, but otherwise critic and painter had very little in common. There was a gap of forty-four years in their ages, but, more important, the younger man was a fastidious, middle-class intellectual, the older an untidy, lower-class bohemian. Meeting first in 1840, when the painter was sixty-five and Ruskin only twenty-one, they never became close friends. To Turner it was disconcerting to be compared, in the inimitable prose of *Modern Painters,** to the Great Angel of the Apocalypse, ''Glorious in conception—unfathomable in knowledge—solitary in power...sent as a prophet of God to reveal to man the mysteries of His Universe.''[59] It took him a long time to recover from a eulogy such as this; for months he was too stunned to show his appreciation to his evangelist. One night in 1844, however, these two incongruous companions chanced to share a carriage returning from a party, and when Ruskin and his friends arrived at Turner's house, the ''Angel of the Apocalypse,'' according to Ruskin, ''vowed he'd be damned if we shouldn't come in and have some sherry. We were compelled to obey,'' Ruskin continued, ''and so drank healths again...by the light of a single tallow candle in the under room.''[60] Turner was sixty-nine at this time, and

*Ruskin's five-volume work, written largely in defense of Turner. The first volume was published in 1843.

becoming more and more of a recluse. His father, who had kept an eagle eye on finances and been in charge of all domestic arrangements, had been dead fifteen years, and Turner depended on such housekeeping help as he could get from Hannah Danby, Sarah's aging niece. It is as well the darkness concealed from Turner's squeamish young guest the dirt and squalor of his house, with its haglike maid of all work and her mangy, half-starved cats.

There is no doubt that the painter had been, in earlier years, more at ease with his admirers. The degree to which this self-sufficient, secretive human being, absorbed in his profession, was capable of lasting friendships is extraordinary. His attachment to Walter Fawkes, a Yorkshire member of Parliament, and to Lord Egremont of Petworth is evidence of the depth of his feelings.

From Fawkes, a patron as early as 1803, Turner acquired a taste for radical politics. He was easily persuaded that Englishmen were on the brink of a frightful precipice; and that, as his mentor pointed out, there was dire necessity for their with-

drawing themselves immediately from "its hollow and crumbling edge." The king should take heed, Turner was told, for Charles I and Louis XVI "were their own executioners."[61] By nature melancholy and apprehensive, the painter was instinctively drawn to such predictions of doom. Moreover, events seemed to bear out Fawkes's forebodings. By 1806 Napoleon was in control of Europe and was waging a war of nerves on England, threatening invasion and enforcing his Continental System, which banned trade with Great Britain. Five hundred British ships had been seized by French privateers; unsold manufactured goods lay piled up on English docks. In 1811, in the industrial centers, where the living conditions of the lower classes were desperate, the Luddite Movement took hold. Bands of workmen systematically destroyed the new machinery to which they attributed their unemployment. The government was ultimately forced to send ten thousand troops into Nottinghamshire, an army comparable to the expedition Wellington had led in 1808 to assist Portugal in its revolt against the French. It is not surprising that Turner's paintings at this time, especially *Hannibal and*

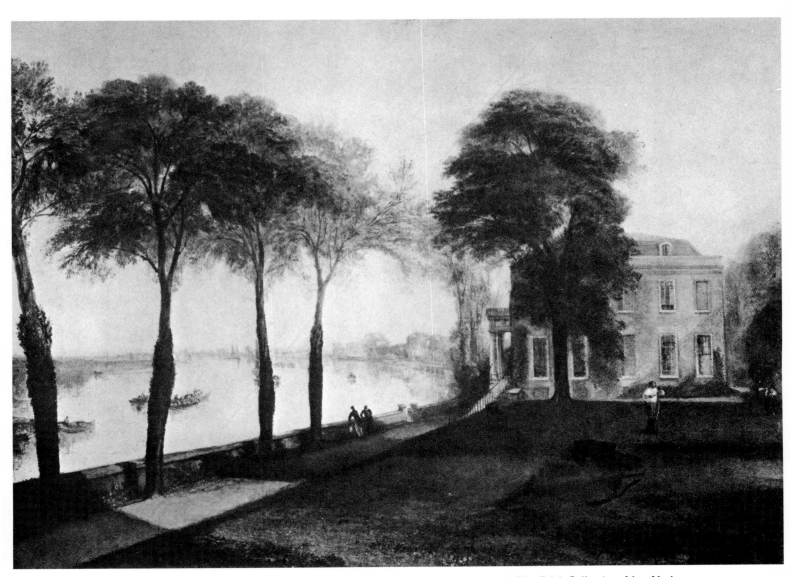

26. *Mortlake Terrace.* 1826. Oil on canvas, 35 x 47½" (88.9 x 120.7 cm.). © The Frick Collection, New York

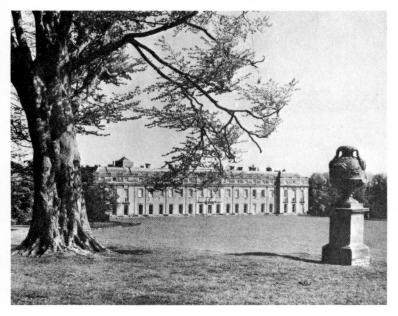

27. Photograph of Petworth House, Sussex.
West front, seen from the park

28. *Jessica*. 1830.
Oil on canvas, 48 x 36¼″ (122 x 92 cm.).
The National Trust.
From the Petworth Collection,
Sussex, England

29. *The Lake, Petworth: Sunset, Fighting Bucks.* c. 1829–30. Oil on canvas, 24¼ x 57½″ (61.6 x 146 cm.).
The National Trust. From the Petworth Collection, Sussex, England

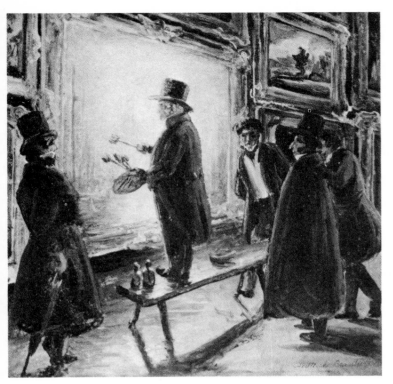

30. Thomas Fearnley, *Turner on Varnishing Day.* 1837
Oil on paper, 9⅛ x 9¼" (23 x 23.5 cm.).
The Arts Council of Great Britain, London.
The N. Young Fearnley Collection

31. Photograph of Mrs. Booth's House, Margate

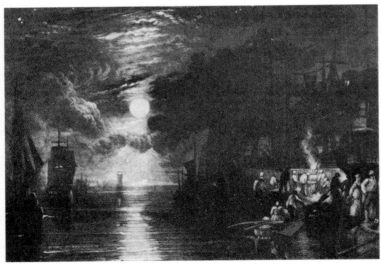

32. Charles Turner, after J.M.W. Turner.
Shields on the River Tyne. 1823.
Mezzotint, 6⅛ x 8½" (15.6 x 21.7 cm.).
British Museum, London

His Army Crossing the Alps (colorplate 12), expressed symbolically his own sense of crisis. But the years passed: Britain's quarter-century struggle against the French Republic and Napoleon ended at Waterloo; Victoria began her long and prosperous reign in 1837; and Turner's revolutionary spirit died away. His pictures became more serene and gained in beauty from being less cataclysmic.

Walter Fawkes died in 1825, leaving a void in Turner's life. He had spent many happy months at Farnley Hall, Fawkes's house in Yorkshire, painting the house, the gardens, the countryside; and he missed desperately this friend and enlightened patron. Four years later Turner's father died. The two Turners had been wonderfully united. Art was beyond "Old Dad's" comprehension, but he knew his son was a genius and that it was his duty to protect him from all distraction; no wife could have been more solicitous. The father's death left the son desolate and brokenhearted.

Luckily, there was a second hospitable house where Turner felt as much at home as at Farnley and where he could to some extent forget his sorrows. Lord Egremont had bought Turner's pictures for many years, and they covered the walls of Petworth, his great country mansion in West Sussex. Turner first visited Petworth in 1809. He was always welcome there, and after his father's death his stays became more frequent and were of longer duration. Petworth was architecturally one of the most beautiful houses in England, and Lord Egremont adorned it with the best contemporary paintings. It is now owned by the National Trust and remains a fascinating monument to his taste.

At Petworth the atmosphere was the opposite of the earnest, radical idealism which prevailed at Farnley. Egremont was a survival from the eighteenth century, with an income of over a hundred thousand pounds a year. His contemporaries were convinced that he had forty-three children, who were all said to have lived at Petworth with their respective mothers. Life must have been chaotic but gay, and many of Turner's paintings of interiors and exteriors of the great mansion and its grounds (see fig. 29 and colorplates 19, 29) seem inspired by a joyous ebullience rare in his work.

There is a vivid description[62] of Turner fishing in the park at Petworth written many years later by Robert Leslie, the son of C. R. Leslie, Constable's biographer. As a child Leslie and his father saw a solitary man struggling to free his line from a stump. "He was smoking a cigar, and on the grass, near him, lay a fine pike." Turner would not break his line, for it was worth, as he said, "quite half a crown." The two Leslies gave what assistance they could, and finally, with the help of a boatman, the line was released. Then "Turner, remarking that it was no use fishing any more after the water had been so much disturbed, reeled up his other lines, and, slipping a finger through the pike's gills, walked off with us toward Petworth House." The child walked behind, looking at the curious little fisherman holding his great fish. "I noticed as Turner carried it how the tail dragged on the grass, while his own coat-tails were but little further from the ground."

Coattails reaching to his ankles were characteristic. Turner usually dressed the same way: in an old, ill-fitting frock coat, a frilled shirt, often dirty, and a much worn top hat. Fig. 30

shows him typically garbed on Varnishing Day at the Royal Academy.

The artist's visits to Petworth ended in 1837 with the death of Lord Egremont. A year before, Turner's dear friend W. F. Wells had also died; and sobbing like a child, he had exclaimed to Clara Wells, "Oh Clara, Clara, these are iron tears. I have lost the best friend I ever had in my life."[63] Turner had become a lonely old man, and it was thus that Ruskin knew him.

It was fortunate for Turner that some years before, while still middle-aged, he had made the acquaintance of two totally different types, a Margate landlady, Sophia Caroline Booth, and her husband. Turner found their company congenial and often stayed at their house. When Booth died in 1833, his widow was in her early thirties. Turner, judging from his affair with Sarah Danby, had a predilection for widows, and from 1834 on he spent much time at Margate. Whether or not Mrs. Booth became his mistress we do not know, but the arrangements were mutually satisfactory, for she was a thrifty, able housekeeper, who made him comfortable in her home. However, Charles Turner, a fellow artist and an engraver (though no relation), voiced the feeling of Turner's acquaintances when he wrote, "What a pity so great a man in talent should not have a more lady-like choice. He could not have introduced her to *his friends.*"[64]

Although Turner seems to have enjoyed an occasional visit from a few chic and glamorous ladies, he did not want other people beating on his door. He felt it was time to move to his final hideout. In late 1846 he took a house in Chelsea, to which he brought Sophia Booth, placing it in her name. Here he was undisturbed by visitors, for he went to extraordinary lengths to conceal his address. He wished to drop quite literally out of sight, although he did reappear occasionally at the Academy and the Athenaeum. In Chelsea he was known to the street urchins as Puggy Booth, and to the tradesmen as Admiral Booth, for he pretended to be a retired naval officer.[65]

His teeth troubled him fearfully and he called in W. Bartlett, a "Surgeon Dentist and Cupper," to make him a false set. They were not a success for Turner's gums were too tender. Six years later, at Ruskin's request, Bartlett wrote a letter describing this strange last phase of the artist's life.[66] "He never told me his real name," Bartlett wrote, "he went by the name of 'Booth'. There was nothing about the House at all to indicate the abode of an artist. The Art Journal and Illustrated London News were always on the Table. He was very fond of smoking and yet had a great objection to anyone knowing of it. His diet was principally at that time rum and milk. He would take sometimes two quarts of milk per day and rum in proportion, very frequently to excess."

This diet of rum and milk probably hastened Turner's decline. Certainly he was drinking too much. Thornbury tells of interviewing two boatmen who used to row Turner on his sketching expeditions on the Thames. "It is still their unspeakable wonder," he wrote, "how a 'man like that' who always took a bottle of gin out with him for inspiration, and never gave them any, could have been a great genius."[67] There are other tales of drink. A fellow Academician with whom Turner had been drinking complained of seeing two cabs. Turner said, "That's all right, old fellow. Do as I do; get into the firsht one"[68]—an anecdote as old as drunkenness itself, but significant in this context.

Turner's alcoholism caused his digestion to fail, and when he was evidently sinking fast, Mrs. Booth sent for the doctor who had attended him at Margate. According to Thornbury, the doctor told Turner that death was near. "Go downstairs," the painter said, "take a glass of sherry and then look at me again." The doctor did so and returned with his opinion unaltered. "Then," remarked Turner, "I am soon to be a nonentity."[69]

The weather for days had been dull and cloudy, and the dying Turner bitterly lamented the absence of sunlight. Just before his death, he was found prostrate on the floor. The sky had cleared, and a ray of sunshine fell on him. He must have been stricken as he struggled toward the window. It was as though some mysterious and lifelong heliotropism impelled him with his last breath to seek the radiance of the sun. The date was December 19, 1851. According to Effie Millais, Ruskin's former wife, who may have been reporting gossip, his hideout was so closely guarded and his assumed name so generally accepted that "it was only by his constantly calling out for Lady Eastlake [the former Miss Rigby] and on her being sent for, that his identity became known."[70]

BETRAYAL

Although Turner changed his will[71] frequently, removing executors, altering individual bequests, adding codicils, he remained steadfast in three wishes:

1. To offer *Dido Building Carthage* (colorplate 13) and *Sun Rising Through Vapour* (colorplate 7) to the Trustees of the National Gallery; if accepted they were to be permanently hung between Claude's *Seaport* and *Mill* (figures 34 and 35). He specified that the installation take place within twelve months of his demise. His executors, in agreement with the Trustees of the gallery, delivered the paintings within the year, and they were held in escrow while the will was contested.

2. To bequeath all his other *finished* pictures to the nation on the condition that a gallery or galleries adjacent to the National Gallery be built to house them. This Turner Museum was to be supported by the state. He allowed ten years for its construction, but until it was built the finished paintings, except for *Dido* and *Sun Rising,* were to remain in his house on Queen Ann Street. His watercolors, drawings, and engravings were to be kept there permanently. He directed that the upkeep and the custodial services of the Queen Ann Street house be the first claim on his estate. The Trustees of the National Gallery, he stated specifically, were to have no power over his pictures until the new building was in existence and the Turner Gallery established. If his wishes were not carried out, the bequest would become void, and if for any reason the Queen Ann Street house then proved impractical, everything was to be sold and the money given to his "charitable institution" (see below).

3. To leave most of his fortune, estimated at about £140,000, to a "Charitable Institution...for the Maintenance and support of Poor and Decayed Male Artists being born in England and of English Parents only and lawful issue." The last condition is psychologically interesting. Turner had no sympathy with bastards, though he appears to have fathered at least two.

As soon as Turner's death became known, whether through Elizabeth Rigby, by then Lady Eastlake, who must have been the first mourner from the outside world, or through Sophia Booth, who of course knew his identity, rumors began to circulate that certain of his relatives to whom he had never paid the slightest attention would contest the will and claim his estate. At first his executors thought the will inviolable and prepared for a public exhibition of his work in Queen Ann Street as directed by his testament. The next of kin, however, claimed that Turner was of unsound mind, and resisted probate. They were overruled by the court. They then appealed to the Court of Chancery (the court presided over by the Lord Chancellor, which was the highest court of justice next to Parliament) on the grounds that it was impossible to place any construction on the will (which was certainly untrue). No one who has read Turner's will and codicils can have the slightest doubt about his intentions. His testament was drawn up by two professional solicitors, and there was never any criticism by the court which cast doubt on the document's clarity or validity. But the relatives argued that even if the document were crystal clear, the bequest of land (in this case about three-quarters of an acre Turner owned at Twickenham) to a charitable institution was illegal according to the Mortmain or Charitable Uses Act. This is a technical question, and the executors, being too lazy or too pusillanimous to pursue the

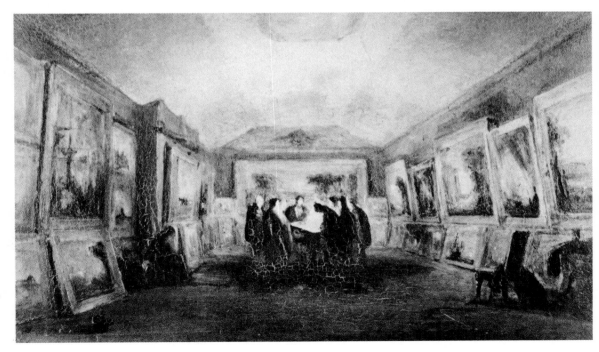

33. George James. *Turner Lying in State in His Gallery, December 29, 1851.* c. 1852. Oil on millboard, 5⅝ x 8⅞" (14.4 x 22.6 cm.). Ashmolean Museum, Oxford, England

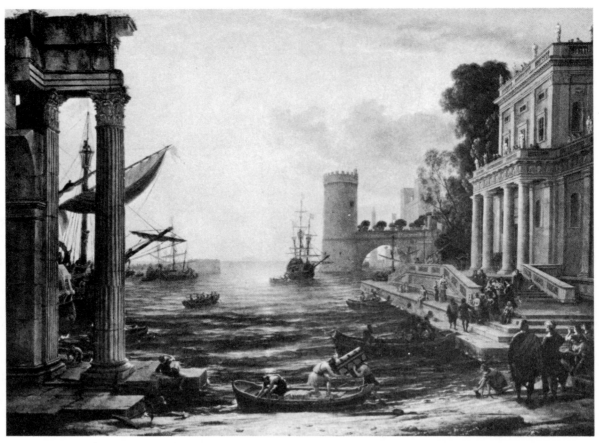

34. Claude Lorrain. *The Seaport: The Embarkation of the Queen of Sheba*. 1648.
Oil on canvas, 58½ x 76¼″ (148.6 x 193.7 cm.). National Gallery, London

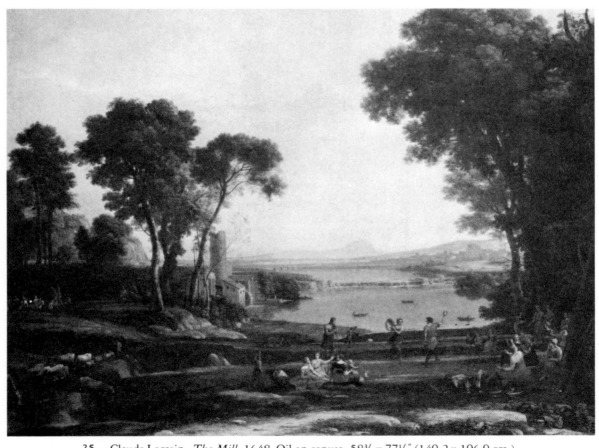

35. Claude Lorrain. *The Mill*. 1648. Oil on canvas, 58¾ x 77½″ (149.2 x 196.9 cm.).
National Gallery, London

issue, settled before the Court of Chancery could hand down a decision. Their excuse was that because of the dilatory proceedings of the court, they might find themselves in the position of the heirs of Jarndyce and Jarndyce, so distressingly described in Dickens' *Bleak House*. But the issues were clear, and the Court of Chancery, as Finberg has pointed out, would doubtless within a reasonable time have declared that as many as possible of Turner's wishes regarding the bequest to his charitable institution be carried out.[72]

It was at this point in the litigation that Turner was let down by Ruskin, whom he had named an executor. In a letter of February 17, 1852, Ruskin wrote to his father, "To enable me to work quietly I must beg you to get me out of the executorship; as the thing now stands it would be mere madness in me to act, and besides, I should get no good by it."[73] Yet in accepting an executorship this friend, whom Turner trusted and who constantly proclaimed his admiration and affection, surely had an obligation to try to see that Turner's plans were accomplished. "The only near relations he has," as Ruskin himself said, "have no legal claim upon him."[74] Ruskin's fellow executors behaved little better. They also saw they would "get no good by it," and likewise declined to take the time and trouble to combat the rapacious demands of Turner's relatives. Shamefully, after the will had been in Chancery for four years they agreed to a settlement which, for the most part, ignored Turner's wishes. Vice-Chancellor Kindersley simply said: "Let the agreement dated November 12, 1855, be carried into effect."

First, the executors gave up all the cash in the estate. The Royal Academy, to which Turner had conditionally left £1,000, ended up with £20,000, and, except for a few individual bequests which were honored, the relatives took the rest. The charitable institution, Turner's lifelong dream, for which he had toiled and saved, was never realized. The executors also gave the relatives the house in Queen Ann Street, frustrating Turner's wish to keep all his pictures in one place until the terms of his bequest were fulfilled. "What is the use of them but together?" he had asked repeatedly. Only if they were kept in a series, he felt, would the key to their meaning be discernible. This was his principal aspiration. It is still unfulfilled. It would seem his despairing pessimism has been justified, the "fallacies of hope" by now proven.

There was to be a further infraction of his will. In bequeathing his paintings to the nation, Turner made a significant division between "finished" and "unfinished" pictures, a distinction which must have seemed important to him. He always places the adjective *finished* before the word *pictures* when he mentions his bequest to the nation, and in his final codicil he repeats *finished* four times. Ruskin's father, who was familiar with the will, wrote his son on February 19 and 21, 1852, that he had visited the painter's studio to examine the bequest. "The very large pictures were spotted but not much. They stood leaning one against another in the low rooms. Some *finished* go to the nation, many *unfinished* not."[75] Vice-Chancellor Kindersley in the Court of Chancery, however, decreed that "all the pictures, Drawings and Sketches by the Testator's hand—without any distinction of finished and unfinished—are to be deemed as well given for the benefit of the public."[76]

Whatever Turner's reasons for wishing his unfinished pictures to remain outside his bequest to the nation, the Vice-Chancellor had no right to ignore this distinction.

The settlement between indifferent executors and avaricious relations was the first betrayal of Turner. Some display of determination on the part of the people he trusted would probably have prevented this triumph of greed. Worse than the agreement with the next of kin, however, was the second betrayal, the ignominious manner in which the Trustees of the National Gallery disregarded the conditions of the bequest. They showed no intention of erecting a Turner Gallery. Their position was supported by the director of the gallery, Sir Charles L. Eastlake, husband of Elizabeth Rigby and one of Turner's close friends. Eastlake held that because Turner's will had been broken, the National Gallery owned all the artist's work subject to no provisions whatever. The Trustees immediately began exhibiting a certain number of Turner's paintings and drawings at Marlborough House. Lord St. Leonards, an eminent lawyer and former Lord Chancellor, was so outraged by this disregard of Turner's clearly expressed conditions that he brought the matter to the attention of the House of Lords in March 1857, just one year after the decree handed down by the Court of Chancery. The same year, in a speech before the Royal Academy, Lord St. Leonards stated that Turner's will, although obscure, was capable of being carried into execution "to the testator's own intentions."[77] But although his words were greeted with cheers, little attention was paid to their import.

The government's next step was to build a series of temporary galleries in connection with the museum which had just been established in South Kensington; when these were grandly opened in December 1859 as "The National Gallery, British School," 103 of Turner's pictures were on display. They had never been so well exhibited, but the conditions of the will were far from being met.

In June 1861, Lord St. Leonards, by now eighty-one years old, brought the matter up a second time. Turner's time limit of ten years would expire in another six months. The Trustees of the National Gallery finally seemed to realize that their disregard of the conditions of the Turner Bequest had put them in a dangerous position—that, indeed, they stood to lose all. It was decided to appoint a Select Committee of Parliament to take action. The committee asked for and received an estimate from the Board of Works for the construction of rooms "fully sufficient for the Turner pictures" to be located at the back of the National Gallery. The cost of the whole project, they were told, would not exceed £25,000, and work could be completed within a year. The report and estimate of the Select Committee seems to have ended the matter. The best the Lords of the Treasury could suggest was that Turner's pictures be removed from South Kensington and exhibited "for the present" in the National Gallery.[78] About two months before the expiration of Turner's time limit, the Keeper of the National Gallery put up a tablet inscribed "Turner's Gallery" at the door of a small room with an adjoining office, from which Dutch and Flemish pictures had been hastily removed. Here were hung, crowded together, some on screens, fewer than one hundred of Turner's pictures. This "temporary" arrangement lasted for years, and the idea of a separate Turner

Gallery was forgotten. An addition to the National Gallery has been built, but no paintings by Turner are exhibited in it.

The "children" of his legacy are scattered. Most of the oils are at the Tate; only a part of them, however, are on exhibition. The key canvases are in the National Gallery, and the drawings and watercolors for the most part are at the British Museum. Here and there one comes across an occasional stray, sometimes in a British embassy, sometimes in a government building.

On the two-hundredth anniversary of Turner's birth, the Royal Academy held the largest exhibition of his work ever assembled, a gesture that would have deeply pleased him. The show, however, remained essentially incomplete. Incredibly, the Trustees of the National Gallery refused to lend his most important works! There is a story, perhaps apocryphal, that Turner used to say, "Art's a rum business!" The treatment accorded him justifies this generalization.

DRAWINGS, WATERCOLORS AND ENGRAVINGS

Turner, like Leonardo da Vinci, drew incessantly. There are over two hundred bound sketchbooks in the British Museum as well as numerous single sheets, a corpus ranging from detailed studies to the merest scribble, just enough to jog the artist's memory. His finest pencil drawings were done early in life; later, his preoccupation with color caused him to neglect somewhat his mastery of pure line. But in many youthful drawings like *Lincoln Cathedral* (fig. 36) he created masterpieces, peerless in their way. In such careful renderings, Turner reveals a mind trained to find unity and simplicity in the most complex subject, and a hand taught to indicate all its essential details, all its separate planes, by the phrasing of each line, by a range of accents. In *Lincoln Cathedral*, for example, the accent varies from the relatively heavy lines of the gables and roofs of the houses, terminated by characteristic dots of black, to the impalpable delicacy of the tracery of the tower, where the lines are almost invisible. Although no other architectural draftsman has equaled the linear organization of such sketches, for Turner they were usually only a means to an end, the basis for exhibitable pictures. In the drawing and the watercolor of the Octagon of Ely Cathedral (figs. 37 and 38), one can see the transformation of such a sketch into a finished painting.

Turner's incomparable control of pencil and watercolor made his work ideal for the printmakers. From his youth, when he worked for John Raphael Smith, the famous mezzotint engraver, he was involved in prints. When he undertook the *Liber Studiorum*, his greatest graphic work, he was able himself to execute all the foundation etchings which the engravers required (fig. 40), and he completed with his own hands the mezzotinting of eleven of the best plates (see *Junction of Severn and Wye*, fig. 41; *Crypt of Kirkstall Abbey*, fig. 42; *Mer de Glace*, fig. 43; and *Source of the Arveyron*, fig. 44). This extraordinary publication, to which I have referred on page 20, remains a unique achievement, one that has never been rivaled as a compendium of landscape styles.

Mezzotinting is a method of engraving by working on a surface previously roughened with a cradle, removing the roughness in places by burnishing to produce the requisite

36. *Lincoln Cathedral.*
Pencil, 10¾ x 8¼" (27.3 x 21 cm.).
British Museum, London

light and shade. As we see it in the *Liber Studiorum*, it is the ideal way of reproducing washes of color, but there is an insuperable disadvantage—the plates wear out rapidly. For pecuniary reasons, therefore, most of Turner's prints came to be done by line engraving, first on copper and later on steel. Although line engraving is a less satisfactory method than mezzotinting, the dissemination of the artist's work was vastly increased. Many of the trial proofs pulled from plates done in both techniques have been preserved, and Turner's corrections in the margins show his familiarity with all the details of printmaking (see *Longships Lighthouse, Land's End*, fig. 48). No one was more aware than Turner of the capabilities and limitations of engraving or more attentive to the reproduction of his own pictures.

The first able engraver to work from Turner's drawings was James Basire, who reproduced the watercolors for the *Oxford Almanack*. Another Oxford subject, *The High Street* (fig. 50), still considered one of Turner's early masterpieces, was engraved by John Pye and S. Middiman. Such topographical engravings were extremely popular before the era of photography. Turner's first important series, *Views in the Southern Coast of England*, was begun in 1811 for W. B. Cooke. The prints were published sporadically until 1827, when the artist, after years of quarreling with the engraver, broke off relations. Other illustrations of picturesque scenery and famous buildings kept him occupied all his life. The titles of the collected engravings explain the nature of these: *Views in Sussex, Rivers of England, Ports and Harbours of England, Picturesque Views in England and Wales*, and *Turner's Annual Tour—Wanderings by the Loire and the Seine*. Between 1830 and 1837 Turner made over three hundred drawings for such illustrations and minutely corrected the print made from each—surely a record. (A typical watercolor and print for *Turner's Annual Tour, Rivers of France* series can be seen in colorplate 42 and fig. 52.)

Book illustrations also form a large part of Turner's oeuvre. He illustrated Albert C. Whitaker's various *Histories*, Francis Haskell's *Tour in Italy*, volumes of poetry by Samuel Rogers, Byron, Scott, Milton, and Thomas Campbell, and other similar publications. Altogether, G. W. Rawlinson in *The Engraved Work of Turner* lists over eight hundred plates made from his drawings, watercolors, and paintings. Few artists have been so prolific or so dedicated. Nothing was permitted to interrupt his work, neither family life nor social activities.

This vast output provided employment for more than eighty engravers, some excellent, some mediocre. Turner quarreled with most of them. They were convinced, probably correctly, that they were being exploited. For, regardless of the contract, Turner constantly demanded free proofs and a number of the first and finest impressions. These he hoarded in his Queen Ann Street house. He felt his immortality depended to some extent on keeping the best examples of his engraved work together.

Once more his wishes were frustrated. After interminable litigation by order of the Court of Chancery all the prints were sold at Christie's in 1873 and 1874. The sale required twenty days and realized over £40,000, or in terms of the value of money today, over $1 million.[79] This dispersal of Turner's carefully garnered evidence of his mastery of printmaking was his final betrayal, the last example of the "fallacies of hope."

37. *The Octagon, Ely Cathedral.* 1794.
Pencil, 30⅜ x 23⅛" (77.2 x 58.8 cm.).
British Museum, London

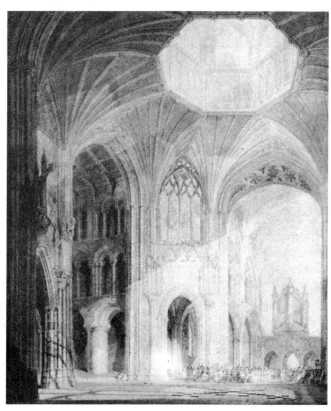

38. *Interior of Ely Cathedral:
Looking Towards the North Transept and Chancel.* 1796.
Watercolor, 24¾ x 19¼" (62.9 x 49.1 cm.).
Aberdeen Art Gallery, Aberdeen, Scotland

39. *Study of the Quarter-Deck of the 'Victory'.* 1805.
Pencil, pen and ink, wash, and watercolor, 15 x 21¾″ (38.1 x 55.2 cm.). British Museum, London

40. Liber Studiorum: *Mer de Glace—Valley of Chamonix—Savoy.* 1812. Etching, 7⅛ x 10⅛″ (18.1 x 25.7 cm.).
British Museum, London

41. Liber Studiorum: *Junction of Severn and Wye.* Published 1811. Etching, aquatint, and mezzotint, 8¼ x 11½″ (21 x 29.2 cm.). British Museum, London

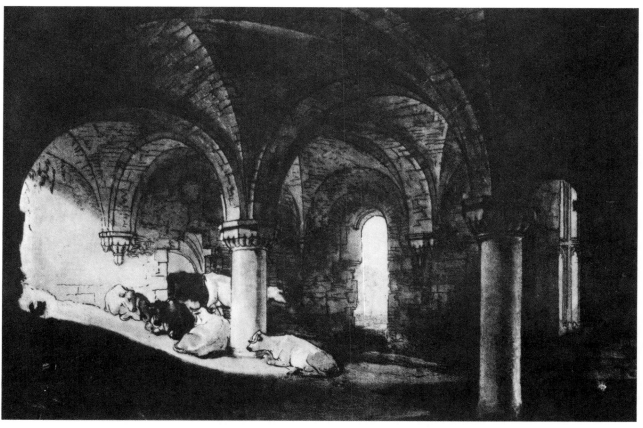

42. Liber Studiorum: *Crypt of Kirkstall Abbey.* Published 1812. Etching, aquatint, and mezzotint, 7¼ x 10½″ (18.4 x 26.7 cm.). British Museum, London

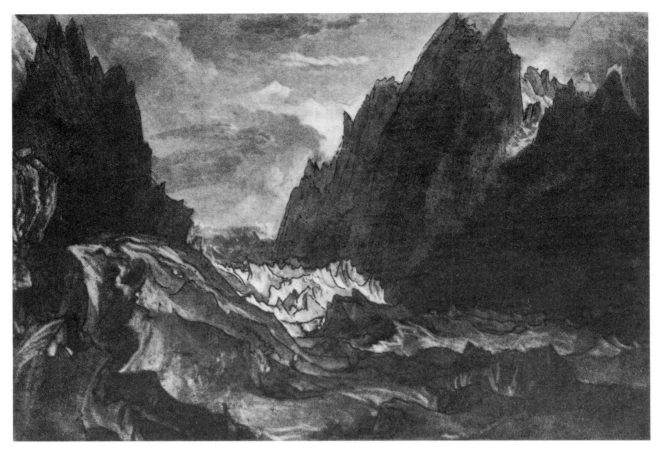

43. Liber Studiorum: *Mer de Glace—Valley of Chamonix—Savoy.* Published 1812.
Etching and mezzotint, 7⅛ x 10⅛″ (18.1 x 25.7 cm.). British Museum, London

44. Liber Studiorum: *The Source of the Arveyron in the Valley of Chamonix, Savoy.* Published 1816.
Etching and mezzotint, 6⅝ x 9½″ (16.8 x 24.1 cm.). British Museum, London

45. Liber Studiorum: *Ships in a Breeze*. Published 1808. Etching and mezzotint, 7⅛ x 10″ (18.2 x 25.8 cm.).
Royal Academy of Arts, London [Engraved by Charles Turner]

46. Liber Studiorum: *Little Devils Bridge over the Russ above Altdorft Swiss*.
Published 1809. Etching and mezzotint, 7¼ x 10½″ (18.4 x 26.7 cm.).
British Museum, London [Engraved by Charles Turner]

47. Liber Studiorum: *Norham Castle on the Tweed.* Published 1816. Etching and mezzotint, 7 x 10¼″ (17.8 x 26.2 cm.).
British Museum, London [Engraved by Charles Turner]

48. William Richard Smith, after J.M.W. Turner. *The Longships Lighthouse, Lands End.* 1836.
Engraving, 6½ x 10″ (16.5 x 25.4 cm.). British Museum, London

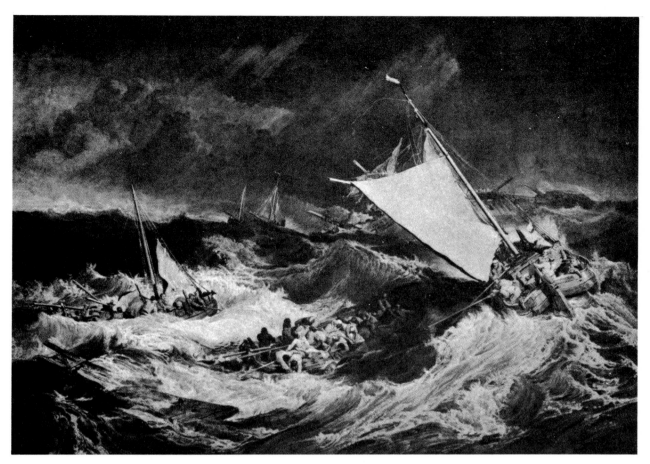

49. Charles Turner, after J.M.W. Turner. *A Shipwreck.* 1806.
Mezzotint, 23⅛ x 32″ (58.6 x 81.3 cm.). British Museum, London

50. John Pye and S. Middiman, after J.M.W. Turner. *The High Street, Oxford.* Published 1812.
Engraving, 18¼ x 24½″ (46.4 x 62.2 cm.). British Museum, London

51. William Miller, after J.M.W. Turner. *Norham Castle, Moonrise.* 1834.
Engraving, 3⅜″ x 5½″ (8.6 x 14 cm.). British Museum, London

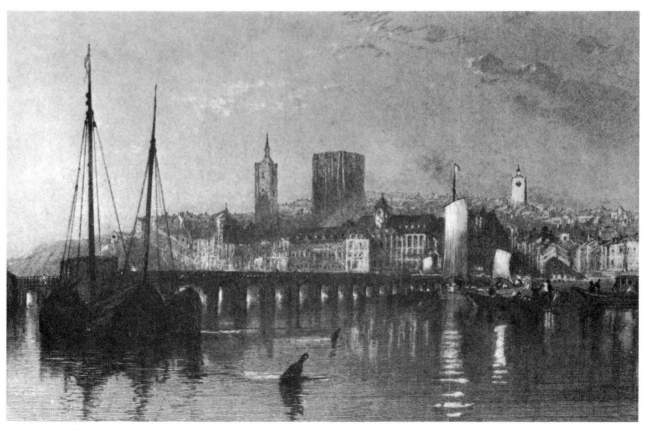

52. R. Brandard, after J.M.W. Turner. *Beaugency.* 1833.
Engraving 3⅝″ x 5½″ (9.2 x 14 cm.). British Museum, London

BIOGRAPHICAL OUTLINE

1775 Joseph Mallord William Turner born April 23 at 21 Maiden Lane, Covent Garden, London, the son of a barber and wigmaker.

1785-86 Sent to live for about a year with his uncle at Brentford, Middlesex. Explored the countryside around Twickenham. First signed and dated drawings.

1789 The "Oxford" sketchbook. Studied with Thomas Malton. In December admitted as a student of the Royal Academy Schools.

1790 First exhibit, a watercolor, at Royal Academy.

1792 First sketching tour in South and Central Wales.

1793 In March awarded the "Greater Silver Pallet" for landscape drawing by the Society of Arts.

1794 First press notices. Began work for Dr. Thomas Monro, copying drawings by J. R. Cozens and others, with Thomas Girtin. This employment lasted about three years.

1795 In June and July toured South Wales and the Isle of Wight.

1796 At the age of twenty-one, sent ten watercolors to the Royal Academy and exhibited his first oil painting.

1797 First tour of the North of England.

1799 In November elected an Associate of the Royal Academy. Moved from his parents' home to 64 Harley Street. Probably met Sarah Danby about this time.

1800 Turner's mother admitted to Bethlem Hospital.

1801 First tour of Scotland.

1802 Elected a full member of the Royal Academy on February 12. After the Peace of Amiens, made his first visit to France and Switzerland.

1804 Death of Turner's mother on April 15. Completed a gallery at 64 Harley Street for the exhibition of his own works.

1806 Visited Knockholt in Kent and stayed with W. F. Wells, at whose suggestion he began the *Liber Studiorum*. The first volume was published in June of the following year.

1807 Elected Professor of Perspective at the Royal Academy.

1809 First visit to Petworth, the seat of Lord Egremont.

1810 First recorded visit to Walter Fawkes at Farnley Hall, Yorkshire; returned there every year until 1824. Acquired house at 47 Queen Ann Street West.

1811 Toured Dorset, Devon, Cornwall, and Somerset in connection with *The Southern Coast*, a series of topographical engravings later published in book form. Began building house at Twickenham, which was completed in 1813 (later called Sandycombe Lodge).

1817 First visit to Belgium, the Rhineland, and Holland.

1818 Received commission to do watercolors for Hakewill's *Picturesque Tour in Italy*. In the autumn visited Edinburgh in connection with Sir Walter Scott's *The Provincial Antiquities of Scotland*.

1819 First visit to Italy.

1820 Worked at enlarging his Queen Ann Street house and building a new gallery.

1821 Visit to France.

1822 In August went to Edinburgh for the State Visit of George IV.

1823 Commissioned to paint *The Battle of Trafalgar* for St. James's Palace; this was completed by May 1824.

1824 Toured East and Southeast England.

1825 Toured Holland, the Rhine, and Belgium. Death of Walter Fawkes on October 25.

1826 Visit to France. Sold Sandycombe Lodge at Twickenham.

1827 Began regular visits to Petworth, which continued until 1837.

1828 Second visit to Italy.

1829 Visit to France. Death of Turner's father on September 21.

1831 Toured Scotland, and stayed at Abbotsford working on illustrations to Scott's poems.

1833 Visit to Paris; it was probably on this trip that he visited Delacroix. Trip to Berlin, Dresden, Prague, Vienna, and probably Venice.

1834 Spent much time at Margate with Sophia Booth. Tour of the Meuse, Moselle, and Rhine.

1836 Toured France, Switzerland and the Val d'Aosta with H.A.J. Munro of Novar.
Exhibited *Juliet and Her Nurse* at the Royal Academy. The attack on this picture in *Blackwood's Magazine* occasioned Ruskin's first letter to Turner.

1837 Death of Lord Egremont on November 11.
Resigned post of Professor of Perspective in December.

1840 First meeting with Ruskin.

1841 Visit to Switzerland.

1842 Visit to Switzerland.

1843 Publication of volume I of Ruskin's *Modern Painters,* written largely as a defense of Turner.

1844 Visited Switzerland, Heidelberg, and the Rhine.

1845 In July chosen, as eldest Academician, to carry out the duties of President of the Royal Academy during Shee's illness. Last trip abroad—to Dieppe and the coast of Picardy—in the autumn.

1846 Took cottage at Chelsea in the name of Mrs. Booth. Lived as a recluse under the pseudonym of Admiral Booth.

1851 Died December 19. Buried at St. Paul's December 30.

NOTES

(Unless otherwise indicated, all Ruskin references are to the Cook and Wedderburn Library Edition of his *Works*, in 39 volumes, published in London by George Allen, 1903–12.)

1. Walter Scott to James Skene, April 30, 1819; quoted in A. J. Finberg, *The Life of J.M.W. Turner, R.A.*, 2nd ed., rev. (London: Oxford University Press, 1967), p. 257.

2. J. G. Millais, *Life and Letters of Sir John Everett Millais, P.R.A.*, 2 vols. (London: Methuen and Co., 1902), 1:56.

3. Walter Thornbury, *The Life of J.M.W. Turner R.A.*, 2 vols. (London: Hurst and Blackett, 1862), 1:74.

4. Finberg, *op. cit.*, p. 443.

5. Joseph Farington, ms. diary, Feb. 11, 1809; quoted in Finberg, *op. cit.*, p. 155.

6. Third codicil to Turner's will [Feb. 1, 1849], Archives of the National Gallery, London.

7. John Ruskin, *Notes on His Drawings of the Late Joseph Mallord William Turner*, vol. 1 (London: Fine Art Society, 1878), #36.

8. Evelina Dupuis to Jabez Tepper, solicitor, Nov. 24, 1865, and Chancery decision of March 19, 1857; see Jack Lindsay, *Turner, His Life and Work* (New York: Harper and Row, 1966), p. 263.

9. Frank Harris, *My Life and Loves* (New York: Grove Press, 1958), p. 400.

10. I am greatly indebted to Andrew Wilton of the staff of the British Museum, who discovered Ruskin's letter in the London National Gallery Library and drew my attention to it.

11. From Charles Eastlake's testimony before the House of Lords, July 15, 1861, recorded in the Archives of the House of Lords in London.

12. Finberg, *op. cit.*, p. 155.

13. Philip Gilbert Hamerton, *Life of J.M.W. Turner, R.A.* (London: Seeley and Co., 1879), p. 368.

14. Ruskin, "Praeterita," *Works*, 5:304–5.

15. Ruskin, "Modern Painters," *Works*, 7:379.

16. Thornbury, *op. cit.*, 1:18.

17. Thornbury, *op. cit.*, 1:66–67.

18. Finberg, *op. cit.*, pp. 36–40.

19. Edward Dayes, *The Works of the Late Edward Dayes*, ed. E.W. Brayley (London: Mrs. Dayes et al., 1805), p. 352.

20. Finberg, *op. cit.*, p. 27.

21. *Ibid.*, p. 28.

22. *Ibid.*, p. 50.

23. John Williams [Anthony Pasquin], "Principal Performances," *Critical Guide*, 1796.

24. Joseph Farington, *The Farington Diary*, ed. James Greig, 8 vols. (London: Hutchinson and Co., 1928), 1:242–43, Oct. 24, 1798.

25. Farington, ms. diary, Jan. 5, 1798; quoted in Finberg, *op. cit.*, p. 45.

26. Finberg, *op. cit.*, p. 127.

27. Thornbury, *op. cit.*, 2:55.

28. Finberg, *op. cit.*, p. 26.

29. Farington, *The Farington Diary*, 1:269–70, May 8, 1799.

30. Finberg, *op. cit.*, p. 67.

31. Finberg, *loc. cit.*

32. *True Briton*, May 4, 1802; quoted in Finberg, *op. cit.*, p. 78.

33. Farington, ms. diary, June 13, 1802; quoted in Finberg, *op. cit.*, p. 81.

34. Farington, *The Farington Diary*, 2:44, Oct. 1, 1802.

35. Finberg, *op. cit.*, pp. 86–91, summarizes these notes.

36. Jack Lindsay, *Turner, His Life and Work* (New York: Harper and Row, 1966), p. 93.

37. Thornbury, *op. cit.*, 2:98.

38. Richard Redgrave and Samuel Redgrave, *A Century of Painters of the English School*, 2 vols. (London: Smith, Elder and Co., 1866), 2:5.

39. Finberg, *op. cit.*, p. 369.

40. See Lindsay, *op. cit.*, p. 82, for a summary of the critics' opinions.

41. Farington, ms. diary, April 15, 1806; quoted in Finberg, *op. cit.*, p. 122.

42. Farington, *The Farington Diary*, 3:244, June 3, 1806.

43. Finberg, *op. cit.*, p. 125.

44. *Ibid.*, p. 126.

45. Clara Wheeler to Mr. Elliot, quoted in Finberg, *op. cit.*, p. 128.

46. Farington, ms. diary, May 5, 1807; quoted in Finberg, *op. cit.*, p. 133.

47. Finberg, *op. cit.*, p. 149.

48. *Ibid.*, p. 170.

49. *Ibid.*, p. 172.

50. Farington, ms. diary, April 8, 1813; quoted in Finberg, *op. cit.*, p. 194.

51. Farington, ms. diary, Oct. 12, 1812; quoted in Finberg, *op. cit.*, p. 195.

52. Thornbury, *op. cit.*, 1:168.

53. *Ibid.*, p. 165.

54. Finberg, *op. cit.*, p. 204.

55. Thornbury, *op. cit.*, 1:173.

56. *Ibid.*, 2:196–97.

57. Ruskin, "Praeterita," *Works*, vol. 35, p. 217.

58. Lindsay, *op. cit.*, p. 158.

59. Ruskin, *Works*, 3:25n. This passage appeared in the first two editions only of *Modern Painters*. It was mercilessly ridiculed by *Blackwood's*, October 1843, p. 42.

60. Ruskin, diary entry for October 20, 1844; see *Works*, 3:xli.

61. Lindsay, *op. cit.*, p. 138, and p. 239, n.12.

62. Robert C. Leslie to Ruskin, June 7, 1884; see Ruskin, "Dilecta," *Works*, 35:571–72.

63. Finberg, *op. cit.*, p. 364.

64. Lindsay, *op. cit.*, p. 176.

65. Thornbury, *op. cit.*, 2:276.

66. W. Bartlett to Ruskin, August 7, 1857; quoted in Finberg, *op. cit.*, p. 437.

67. Thornbury, *op. cit.*, 2:163.

68. Bernard Falk, *Turner the Painter* (London: Hutchinson and Co., 1938), p. 119.

69. Thornbury, *op. cit.*, 2:275.

70. Millais, *op. cit.*, 1:158.

71. The will and other documents mentioned in this chapter are in the archives of the National Gallery in London, unless otherwise noted.

72. Finberg, *op. cit.*, p. 443.

73. John Ruskin to J. J. Ruskin, Feb. 17, 1852, *Works*, 13:xxx.

74. John Ruskin to J. J. Ruskin, Jan. 1, 1852, *Works*, 13:xxviii.

75. J. J. Ruskin to John Ruskin, Feb. 19 and 21, 1852, *Works*, 13:xxvii.

76. Trimmer v. Danby, 19 March 1856, Archives of the House of Lords.

77. Finberg, *op. cit.*, pp. 445–47.

78. Finberg, *op. cit.*, pp. 449–50.

79. W. G. Rawlinson, *The Engraved Work of J.M.W. Turner, R.A.* 2 vols. (London: Macmillan and Co., 1908), 1:lxvii.

80. Thornbury, *op. cit.*, 1:75–77.

81. Williams, "Principal Performances."

82. Farington, ms. diary, Jan. 5, 1798; quoted in Finberg, *op. cit.*, p. 45.

83. R.A. catalogue of 1798, no. 527.

84. Wordsworth, "Composed upon an Evening of Extraordinary Splendor and Beauty," in *Poetical Works of William Wordsworth* (New York: Oxford University Press), p. 457.

85. Quoted in W. Jerdan, *An Autobiography* (London: 1853), 4:240.

86. Exod. 12:29–30.

87. Farington, ms. diary, Feb. 13, 1802; quoted in Finberg, *op. cit.*, p. 77.

88. Farington, ms. diary, Feb. 27, 1802; quoted in Finberg, *loc. cit.*

89. Ruskin, "Pre-Raphaelitism," *Works*, 12:378.

90. Lindsay, *op. cit.*, p. 91.

91. Ruskin, *Notes on the Turner Gallery at Marlborough House*, 1856 (London: Smith, Elder and Co., 1857), p. 11.

92. Finberg, *op. cit.*, pp. 118–19.

93. Finberg, *op. cit.*, p. 135.

94. Turner's will, Archives of the National Gallery, London.

95. Hamerton, *op. cit.*, p. 100.

96. Finberg, *op. cit.*, pp. 141–42.

97. *Review of Publications of Art*, 1808; quoted in Finberg, *op. cit.*, p. 142.

98. For discussion of the dating, see no. 138 in *Turner*, Catalogue of the Royal Academy Exhibition of 1974–75 (London: The Tate Gallery, 1974).

99. *Ibid.*, no. 87.

100. Constable to Maria Bicknell, August 30, 1860. A photostat of the original is in the files of the National Gallery of Art in Washington, D.C.

101. C. R. Leslie, *Memoirs of the Life of John Constable, R.A.* (London: The Medici Society, 1937), p. 403.

102. R.A. catalogue of 1812, no. 258.

103. Thornbury, *op. cit.*, 2:87–88.

104. *Morning Chronicle*, May 1, 1815; quoted in Finberg, *op. cit.*, p. 219.

105. Alaric Watts, ms. "Biographical Sketch," 1853; quoted in Finberg, *op. cit.*, pp. 290–91.

106. George Jones, ms. "Recollections," Oxford, Ashmolean Museum, quoted in John Gage, *Colour in Turner* (London: Studio Vista; New York: Praeger, 1969), p. 31.

107. William Hazlitt, "Round Table Essays," quoted in Finberg, *op. cit.*, p. 241.

108. Farington, ms. diary, June 5, 1815; quoted in Finberg, *op. cit.*, p. 340.

109. *Athenaeum*, May 11, 1833; quoted in Finberg, *op. cit.*, p. 340.

110. John Gage, *Turner: Rain, Steam, and Speed* (London: Penguin Press, Allen Lane; New York: The Viking Press, 1972), p. 171.

111. Farington, ms. diary, April 29, 1818; quoted in Finberg, *op. cit.*, p. 251.

112. *Morning Chronicle*, May 1818, quoted in Finberg, *op. cit.*, p. 251.

113. C. R. Leslie, *op. cit.*, p. 275.

114. Ruskin, "Modern Painters," *Works*, 3:249n.

115. *Ibid.*, 3:250n.

116. Ruskin, "The Harbours of England," *Works*, 13:47n.

117. Ruskin, lecture on Turner delivered Nov. 15, 1853, *Works*, 12:131. Ruskin first heard the anecdote from George Jones and recorded it in his diary entry for May 22, 1843.

118. Finberg, *op. cit.*, p. 303.

119. Thornbury, *op. cit.*, 1:221.

120. Turner to James Holworthy, quoted in Finberg, *op. cit.*, p. 297.

121. Frederick Goodall, *Reminiscences* (London: Walter Scott Publishing Co., 1902), p. 124.

122. Gage, *op. cit.*, pp. 129–31.

123. Ruskin, "The Turner Bequest: The Oil Pictures," *Works*, 13:137.

124. Ruskin, *Notes on the Turner Gallery at Marlborough House*, p. 44.

125. Finberg, *op. cit.*, p. 333.

126. C. R. Leslie, *Autobiographical Recollections* (Boston: Ticknor and Fields, 1860), p. 138.

127. *Ibid.*, p. 135.

128. Thornbury, *op. cit.*, 1:221.

129. L. Cust, "The Portraits of J.M.W. Turner," *Magazine of Art*, 1895, pp. 248–49. See also Gage. *op. cit.*, p. 264, n.152.

130. Finberg, *op. cit.*, p. 444, n.1.

131. Kenneth Clark, *The Romantic Rebellion* (London: John Murray and Sotheby Parke Bernet Publications; New York: Harper and Row, 1973), p. 223.

132. Report of the Select Committee of the House of Lords, March 19, 1857.

133. *The Art Journal*, 1860, p. 100; quoted in Finberg, *op. cit.*, pp. 351–52.

134. Thornbury, *op. cit.*, 1:195.

135. Gage, *op. cit.*, p. 194.

136. René Gimpel, *Diary of an Art Dealer* (New York: Farrar, Straus and Giroux, 1966), pp. 25–27.

137. Michael Kitson, "Un nouveau Turner au Musée du Louvre," *La Revue du Louvre*, 19 (1969): 247.

138. Kitson, *loc. cit.*

139. Finberg, *op. cit.*, p. 363.

140. Ruskin, "A Reply to Blackwood's Criticism of Turner," *Works*, 3:635–40.

141. *Ibid.*, 3:635n. "Maga," a contraction of "Magazine," was the name by which *Blackwood's* was familiarly known.

142. Oscar Wilde, "The Critic as Artist with Some Remarks on the Importance of Doing Nothing, a Dialogue," Part I, 1890. Reprinted in *The Artist as Critic, Critical Writings of Oscar Wilde*, Richard Ellman, ed. (London: W. H. Allen, 1970), p. 366.

143. Ruskin, *Notes on the Turner Gallery at Marlborough House*, pp. 79–80.

144. Ruskin, *loc. cit.*

145. In Finberg, *op. cit.*, pp. 372–73.

146. Graham Reynolds, *Turner* (London: Thames and Hudson; New York: Harry N. Abrams, 1969), pp. 178–79.

147. Ruskin, "Modern Painters," *Works*, vol. 3, pp. 571–72.

148. Finberg, *op. cit.*, p. 390.

149. Ruskin, "The Turner Bequest: the Oil Pictures," *Works*, 13:161, #530.

150. Ruskin, *loc. cit.*

151. Gage, *op. cit.*, p. 201.

152. Turner's annotated copy of Goethe's *Theory of Colours* is in the C.W.M. Turner collection. See Gage, *op. cit.*, pp. 173–88, for a discussion of the marginalia.

153. Clark, *op. cit.*, p. 260.

154. R.A. catalogue of 1843, no. 553.

155. *Ibid.*, no. 554.

156. Ruskin, "Modern Painters," *Works*, 7:431.

157. *Ibid.*, 7:452–53.

158. Thackeray, *Fraser's Magazine*, June 1844; quoted in John Gage, *Turner: Rain, Steam, and Speed* (London: Penguin Press, Allen Lane; New York: The Viking Press, 1972), p. 14.

159. Luke Herrmann, *Ruskin and Turner* (London: Faber, 1968; New York and Washington, D.C.: Praeger, 1969), p. 96.

160. *Ibid.*, p. 98.

161. Millais, *op. cit.*, p. 157.

162. Ruskin to J. J. Ruskin, *Works*, 13:xxiv–xxv.

163. Martin Butlin, *Watercolours from the Turner Bequest 1819–1845* (London: The Tate Gallery, 1968), unpaginated.

COLORPLATES

FISHERMEN AT SEA

("The Cholmeley Sea Piece")

Exh. R.A. 1796. Oil on canvas, 36 x 48⅛" (91.5 x 122.5 cm.)

Tate Gallery, London

In 1796, at the age of twenty-one, Turner sent to the Royal Academy ten watercolors and one oil. Judging from contemporary descriptions, the solitary oil was almost certainly *Fishermen at Sea.* The engraver Edward Bell, according to Thornbury, said that Turner's "first oil picture of any size or consequence" was "a view of flustered and scurrying fishing boats in a gale of wind off the Needles, which General Stewart bought for ten pounds."[80] The menacing Needles, sharply pointed chalk cliffs to the west of the Isle of Wight, show clearly in this picture. Turner had made a tour of the Isle of Wight in the summer of 1795, and had filled a sketchbook with drawings of the jagged coastline.

The painting received excellent comments when it was exhibited. One critic, John Williams (who took the pseudonym of Anthony Pasquin), wrote, "We recommend this piece, which hangs in the Ante-Room, to the consideration of the judicious: it is managed in a manner somewhat novel, yet the principle of that management is just: we do not hesitate in affirming, that this is one of the greatest proofs of an original mind in the present pictorial display: the boats are buoyant and swim well, and the undulation of the element is admirably deceiving."[81]

That Turner was still inexperienced in oils is evident in the painting of the moon. The clouds seem to continue behind it! It is, however, remarkable that he should show, even in extreme youth, such a strong feeling for the dynamic power of water and for man's struggle with this elemental force, two themes on which he created variations for the rest of his life. He spoke constantly about the meaning of his paintings, which could only be understood, he said, if they were seen together. In this, his first exhibited oil, their leitmotiv is stated: it is man's destiny to fight against overwhelming odds, a battle, he implies, that will end in ultimate defeat, in the ever-recurring "fallacies of hope."

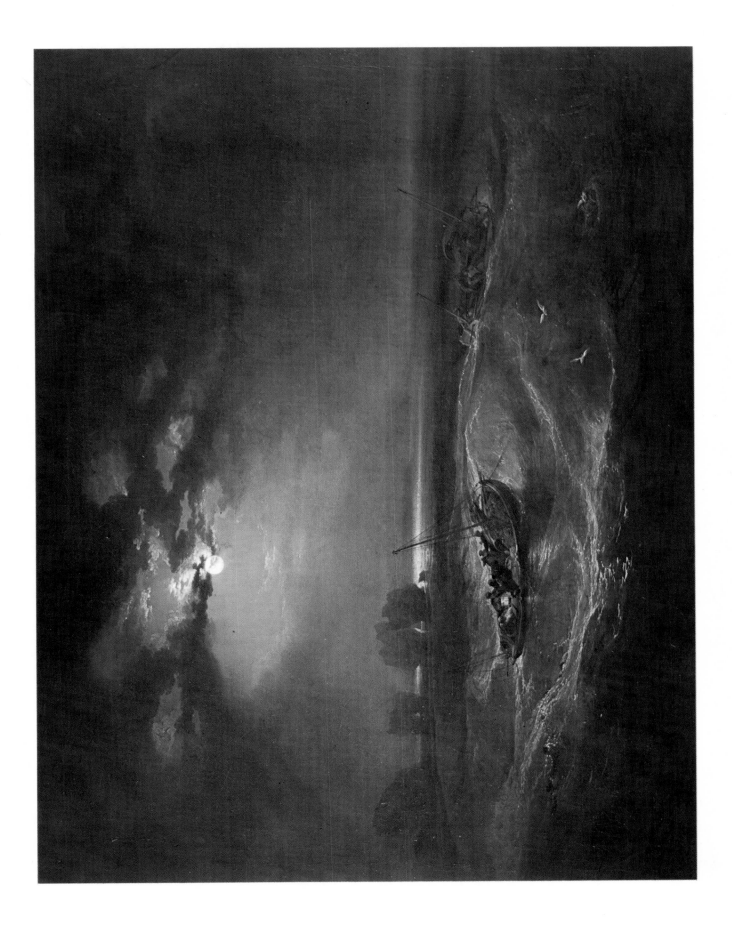

BUTTERMERE LAKE, WITH PART OF
CROMACK WATER, CUMBERLAND: A SHOWER.

Exh. R.A. 1798. Oil on canvas, 36⅛ x 48" (91.5 x 122 cm.)

Tate Gallery, London

In June 1797, Turner traveled north to see as many romantic sites in Yorkshire as possible and also to sketch the picturesque scenery of the English lakes. When he returned to London, he painted *Buttermere Lake* from one of these sketches. It was on seeing this work that the painter John Hoppner made his fatuous misjudgment: ''A timid man afraid to venture.''[82] Yet this picture is, by comparison with eighteenth-century landscapes, a revolutionary statement. Turner, going far beyond the capabilities of Gainsborough and Wilson, has grasped the grandeur of these lowering mountains encircled by a rainbow reflected in the calm water.

For his entry for this painting in the Academy catalogue of 1798, he quoted from *The Seasons (Spring)* by the Scottish poet James Thomson. He was to repeatedly use passages from Thomson to supply an interpretation of his landscapes.

Till in the western sky the downward sun
Looks out effulgent—the rapid radiance instantaneous strikes
Th'illumin'd mountains—in a yellow mist
Bestriding earth—the grand ethereal bow
Shoots up immense, and every hue unfolds.[83]

How stilted and conventional Thomson's poetry now seems! In fairness to the poet, however, it must be pointed out that Turner has put together lines from various parts of the passage and even added a few words of his own. He enjoyed scribbling verse and was well read in eighteenth-century poetry; but apart from Byron, he was insensitive to the great poets of his own generation, who were so close to him in their feeling for nature. He never chooses a poem by Keats, Shelley, or Wordsworth to elucidate his pictorial visions; yet how much more precise and forceful than the verses of Thomson are these lines from Wordsworth, which describe the transfiguration we sometimes feel when, after a shower, sunlight suddenly breaks through, illuminating a patch of countryside still overshadowed by darkling mountains.

No sound is uttered,—but a deep
 And solemn harmony pervades
The hollow vale from steep to steep
 And penetrates the glades.
Far distant images draw nigh
Called forth by wondrous potency
Of beamy radiance, that imbues
Whate'er it strikes with gem-like hues.

Thine is the tranquil hour, purpureal Eve!
 But long as god-like wish, or hope divine,
Informs my spirit, ne'er can I believe
 That this magnificence is wholly thine!
From worlds not quickened by the sun
A portion of the gift is won;
An intermingling of Heaven's pomp is spread
On ground which British shepherds tread.[84]

Turner, apparently an agnostic, would not have approved of the last stanza with its teleological message. Perhaps that is why he ignored Wordsworth's poetry. But Wordsworth's liking for Turner's painting was no greater than the artist's for his verse. When the poet saw *Jessica* (fig. 28) at the Royal Academy show in 1830, he said to the journalist William Jerdan, ''Did you ever see anything like that?... It looks to me as if the painter had indulged in raw liver when he was very unwell.''[85]

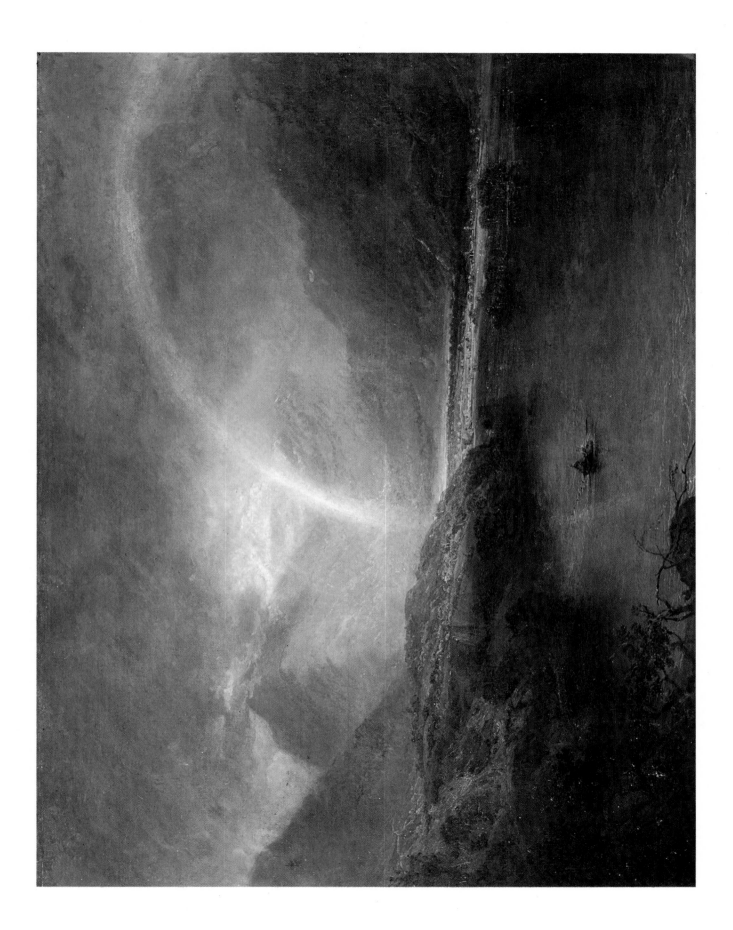

THE TENTH PLAGUE OF EGYPT

Exh. R.A. 1802. Oil on canvas, 57½ x 93½" (146 x 237.5 cm.)

Tate Gallery, London

In 1800 Turner painted *The Fifth Plague of Egypt* (fig. 9), his first historical picture and his largest canvas up to that time. The magnificent effect of the storm sweeping across the pyramids and over the desolate countryside was inspired by an actual thunderstorm he had seen on a journey to Wales and had drawn the previous year. The intensity of his observation of natural phenomena, particularly when of inordinate violence, is equaled only by the tenacity of his visual memory. His tempests are never devised, like stage scenery. They are always based on actual experiences.

The Fifth Plague, which combines the devastation of a whirlwind with the ruin of disease, was a subject which appealed to the writer and collector William Beckford, that strange product of Romanticism, who was absorbed by concepts of dread, destruction, and death. Beckford acquired the painting, and this greatly encouraged Turner to continue working with historical themes.

In 1802 Turner tried to repeat his success with the painting shown here, *The Tenth Plague of Egypt*, illustrating the Biblical verses "And it came to pass that at midnight the Lord smote all of the first born in the land. And Pharaoh rose, he and all the Egyptians, and there was a great cry in Egypt; for there was not a house where there was not one dead."[86] In the interval between the two paintings of Plagues Turner had scrutinized Poussin's work at Bridgewater House, and the results of his study can be seen here, especially in the frontality of the composition, which is typically Poussinesque. Though *The Tenth Plague* received an excellent press, it remained unsold. In 1810, eight years after *The Tenth Plague* was exhibited at the Royal Academy, Turner made a list of the paintings which remained on his hands. He valued the painting at only £100. But even at this price it was not purchased, and so became part of the Turner bequest to the nation.

The technique of this and other early pictures by Turner fascinated Joseph Farington, who described in his diary what he learned. Turner, he writes, "paints on an absorbing ground prepared by Grandi [Sebastian Grandi, his assistant] and afterwards pumissed by himself. It absorbs the oil even at the fourth time of painting over. When finished it requires three or four times going over with mastic varnish to make the colours bear out. He uses no oil but Linseed oil. By this process he thinks he gets air and avoids any *horny* appearance."[87] It was a sound procedure, and these early paintings have, on the whole, lasted better than his later works.

A fortnight passed, and the older Academician called on Turner to learn more. He found Grandi in the studio and got him to "lay me some absorbing grounds." Farington observed that Turner's palette consisted of a very limited number of pigments, as it did throughout his life: "white, Yellow Oker, Raw and burnt Terra di Sienna, Venetian red, Vermilion, Umber, prussian blue, blue Black, Ultra-marine. Linseed oil only."[88] That an established artist like Farington should have been so deeply impressed by the technical procedures of a youth of twenty-seven, who had been elected a full Academician only a few days earlier, is an indication of Turner's early renown.

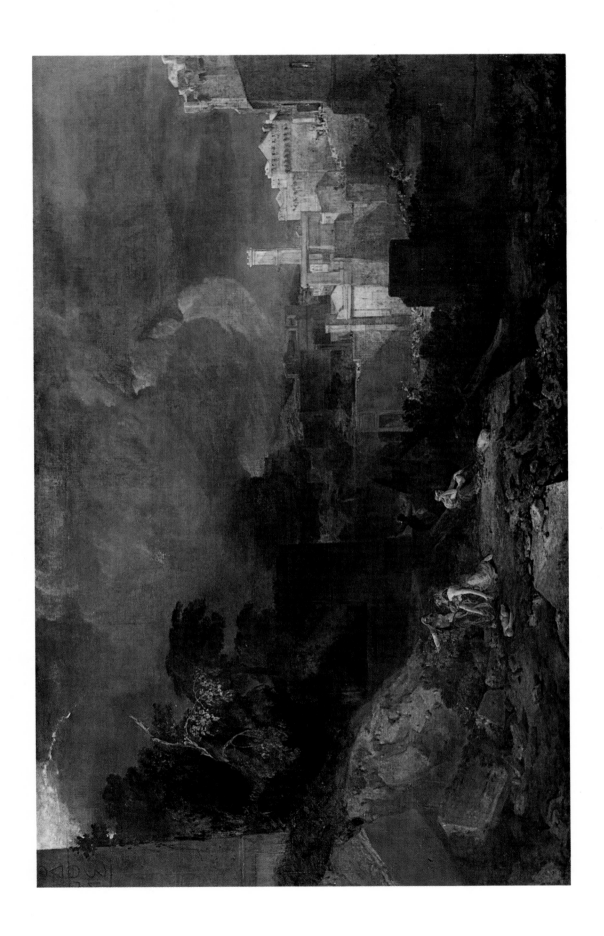

CALAIS PIER, WITH FRENCH POISSARDS PREPARING FOR SEA: AN ENGLISH PACKET ARRIVING

Exh. R.A. 1803. Oil on canvas, 68 x 95 ⅜" (172.5 x 242 cm.)

National Gallery, London

As soon as the Treaty of Amiens was signed in 1802, Turner decided to make his first journey to the Continent. On July 15 he crossed the Channel. The weather was stormy, and his packet was forced to wait outside Calais for the tide to rise, since a rising tide was necessary to sail over a sandbar at the mouth of the harbor. Turner became impatient, and he and several others hired a boat to take them ashore. It was nearly swamped before they could land, and they were in considerable danger. As soon, however, as Turner was on the pier, he began sketching the French fishermen getting their boats under way. The year after his trip to France, he sent this painting, which was based on his sketches, to the Royal Academy.

Turner was typically English in thinking himself vastly superior to the French. His respect for their seamanship was probably not enhanced by his experience on the tender. Doubtless feeling himself cheated in this hazardous trip ashore, he calls the sailors *poissards*. The word is now obsolete, but then meant *pickpocket* or *rogue*. He himself could handle a boat skillfully, and there is an element of satire in his picture, just as there is much more obviously in Hogarth's *Calais Gate* (fig. 12). The skiff trying to get away from the jetty will surely be dashed to pieces, blown against the dock by the gale; yet the man in the stern is doing nothing to prevent the calamity. Instead he is holding up a bottle of cognac, furious that his wife on the pier has kept back a second flagon. Another man grasps an oar, but the other oar seems to have gone overboard. No one is hoisting a sail. There is general confusion everywhere. By contrast, the English packet, which is beating up to the pier, shows how a boat should be sailed.

Ruskin tells us that when Thomas Goff Lupton was engraving *Calais Pier* a quarter of a century later, Turner seems suddenly to have become displeased with his composition. He drew half a dozen more boats and rearranged the others, causing irreparable confusion, and in the end the plate had to be abandoned. While Turner was fussing with the engraving, however, he noticed in his painting "a little piece of luxury," to quote Ruskin, "a pearly fish wrought into hues like those of an opal. He stood before the picture for some moments, then laughed, and pointed joyously to the fish: 'They say that Turner can't colour' and turned away."[89] The fish, alas, has faded, but how sharply one senses in this little anecdote Turner's sensitivity to criticism! His defense was his strange, wry humor, as complicated and obscure in its way as the structure of his lectures or the syntax of his poems.

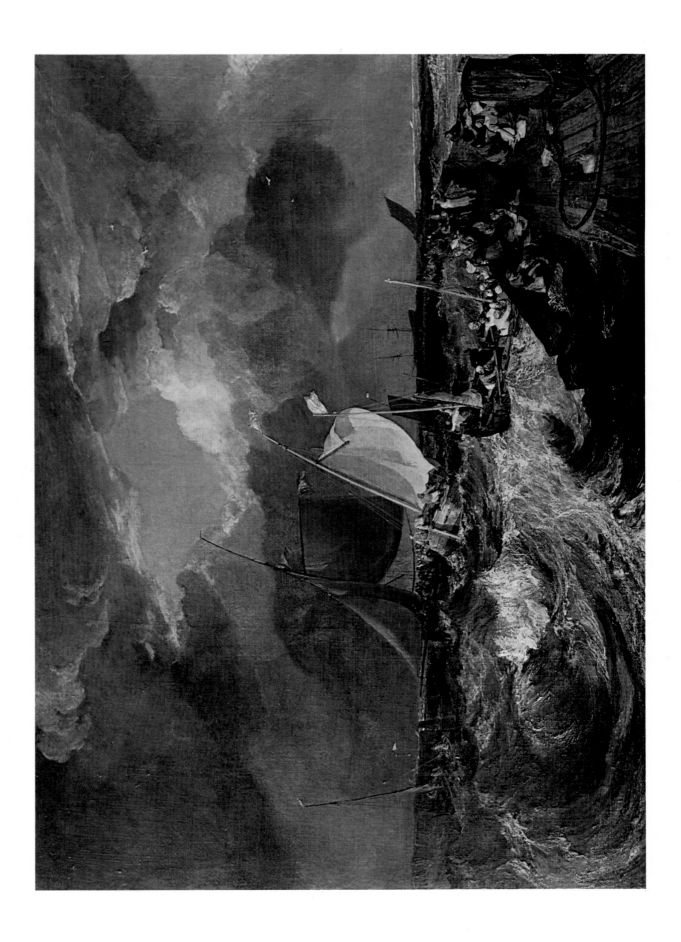

COLORPLATE 5

THE SHIPWRECK: FISHING BOATS
ENDEAVOURING TO RESCUE THE CREW

Exh. Turner's Gallery, 1805. Oil on canvas, 67 1/8 x 95 1/8" (170.5 x 241.5 cm.)

Tate Gallery, London

In 1804 Turner had quarreled with Farington over protocol at a council meeting of the Royal Academy. Afterward, he withdrew for some time from all the society's activities. The Academy, he felt, had broken up into bitterly antagonistic cliques. In 1805, instead of sending his usual group of pictures to the annual exhibition, he decided to devote all his attention to his own recently established gallery and sent invitations to his fellow Academicians to ''visit his exhibition at home.'' The most important picture he showed was *The Shipwreck,* or *The Storm*, as it was called at first. Farington mentions that his friend Hoppner thought all the pictures in the Turner show ''rank, crude, and disordered,'' and Benjamin West said they tended to imbecility.[90] The explanation for the hostility of these artists, at least to *The Shipwreck*, can be easily explained. Turner had presented them with a composition of the greatest originality but one impossible to analyze in classical terms. A mass of agitated and conflicting lines is used to express the turmoil of imminent disaster. The stability of the conventional Dutch seascape has been transformed by a gale of wind into a fearful chaos, a melee of mountainous waves, flapping sails, sinking boats, and men about to drown. This is the essence of the Romantic attitude toward nature: the force of the elements overwhelming the puny efforts of human beings. It is a theme which Turner was frequently to repeat, as he again and again portrays, in Ruskin's words, ''the utmost anxiety and distress, of which human life is capable.''[91]

In spite of the animadversions of Hoppner and West, *The Shipwreck* was an immediate success. Sir John Leicester, a great collector of contemporary English painting, bought it at the opening of the exhibition for three hundred guineas, and Charles Turner asked whether he might make and publish a large mezzotint of the painting (fig. 49). He paid twenty-five guineas for the right of reproduction, and a prospectus was issued: ''C. Turner has the pleasure to inform his friends, as it will be the first engraving ever presented to the public from any of Mr. W. Turner's pictures, the print will be finished in a superior style.... Gentlemen desirous of fine impressions are requested to be early in their applications, as they will be delivered in order as subscribed for.''[92] Although the engraver asked that half the money (two guineas for prints, four guineas for proofs) be paid on subscribing, the other half on delivery, ''which will be December next 1805,'' proofs and prints were not forthcoming until January 1807. But everyone agreed the result was superb. Charles Turner's engraving was the first of many prints after Turner's pictures. These disseminated the artist's work, increased his fame, and helped to keep him prosperous during the years when Sir George Beaumont's attacks diminished the sales of his paintings.

COLORPLATE 6

THE BLACKSMITH'S SHOP

Exh. R.A. 1807. Oil on panel, 21⅝ x 30⅝" (55 x 78 cm.)

Tate Gallery, London

To fully understand Turner's work, one must bear in mind two of his major characteristics: competitiveness and avariciousness. Both of these qualities help to account for this picture, which otherwise would seem strangely out of place in his oeuvre. Anecdotal paintings had become the fashion, but Turner was essentially a painter of the heroic. For several years the pictures he had shown at the Royal Academy, many of which remained unsold, had been severely mauled by the critics. He was disappointed by the lack of sales, and he was sensitive to critical denigration. It was apparent that his search for sublimity did not suit the taste of the times. Therefore he set out to prove that he could paint a storytelling picture as well as David Wilkie or any of the genre painters of his generation. For his effort in this unfamiliar vein, he chose a subject with a title long enough to have been the topic sentence of an essay on economics: *A Country Blacksmith disputing upon the Price of Iron, and the Price charged to the Butcher for shoeing his Poney.* Although somewhat overburdened by this descriptive label, the picture is a gem of its kind—a homely, tranquil episode of everyday country life with a simplicity that reminds one of the beauty of Wordsworth's early verse. It also proves that Turner could handle the subtle gradations of interior light as brilliantly in oil as he had done previously in watercolor.

On the whole the painting was well received by press and connoisseurs. Peter Cunningham in his *Memoir of Turner* says that *The Blacksmith's Shop,* as the painting came to be called, was intended to put Wilkie's "nose out of joint," and to that end Turner "blew the bellows of his art on his *Blacksmith's Forge*."[93] It has been pointed out, however, that *The Blind Fiddler* (fig. 15), Wilkie's major entry at the Academy exhibition, and Turner's genre scene were hung far apart, and that the furnace in *The Blacksmith's Shop* puts forth the palest of yellow flames, just visible amidst clouds of smoke. Wilkie's picture, though far inferior in chromatic harmony, is stronger in color.

Turner's hope of making money from genre painting was not disappointed. In 1808, the year after it was shown, *The Blacksmith's Shop* was purchased for 100 guineas by Sir John Leicester. In 1827 Leicester died; and to the consternation of the artists whose work he had bought, his superb collection was put up for auction. Their fears, however, were groundless, and prices were satisfactory, some even on the high side. Turner repurchased *The Blacksmith's Shop* for 140 guineas. Although he did not continue to work in this style, he could not bear to be separated any longer from his little genre scene, painted so lovingly eighteen years earlier.

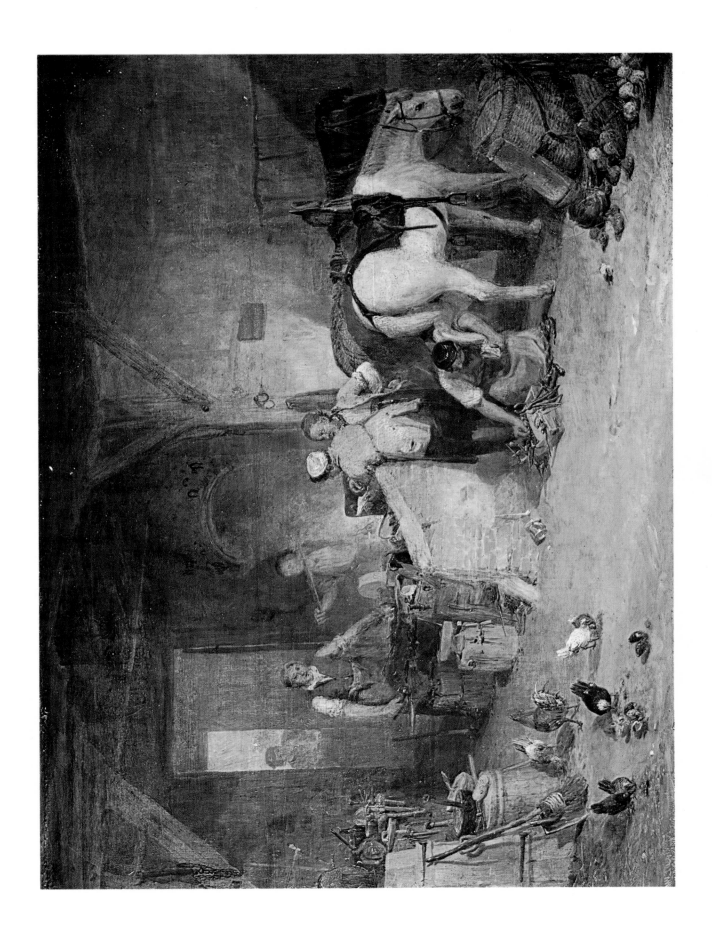

SUN RISING THROUGH VAPOUR:
FISHERMEN CLEANING AND SELLING FISH

Exh. R.A. 1807. Oil on canvas, 53 x 70½" (134.5 x 179 cm.)

National Gallery, London

Exhibited at the Royal Academy the same year as *The Blacksmith's Shop, Sun Rising Through Vapour* is one of the two paintings Turner believed would guarantee his immortality. In his will he left it and *Dido Building Carthage* ''upon the following reservations and restrictions that is to say I direct that the said pictures or paintings shall be hung, kept and placed that is to say Always between the two pictures painted by Claude the Seaport [fig. 34] and Mill [fig. 35].''[94]

At first it may seem surprising that Turner chose this particular work for such signal honor, but the explanation is simple. He wanted a painting of roughly the same size as *The Mill,* and one that also dealt with a contemporary scene. Thus the desired competition would be on equal terms. He must have thought that his naturalism would expose the artificiality of Claude, and, if one accepts this standard, he is right and is the obvious winner. The misty atmosphere of the fishing scene is precisely rendered, with the grayish water in exact relation to the pale blue of the sky. But Claude in other ways carries off the prize. He works freely from his imagination and treats his colors arbitrarily. He has made the river in *The Mill* a deep blue so that, with the foliage and the colorful figures in the foreground, he might attain greater chromatic resonance. By comparison, Turner's painting seems a little pallid, almost a monochrome. *Sun Rising Through Vapour,* however, was painted when Turner was still young. In his later work naturalism fades out, and his landscapes, in their brilliant, prismatic tones, leave Claude far behind.

Turner was generally a shrewd judge of the salability of his paintings. When in 1810 he valued the pictures still on his hands, he marked down all his important large canvases, *Trafalgar, Calais Pier, Spithead, Shipwreck, Tenth Plague,* etc., to roughly £100 apiece. But he estimated that *Sun Rising Through Vapour* would fetch a larger sum, at least £300. He was correct. The other pictures were still in his studio when he died, whereas *Sun Rising Through Vapour* was bought by Sir John Leicester in 1818 for 350 guineas. In 1827, after the death of Sir John, who had become Lord de Tabley earlier that year, Turner repurchased the painting at the De Tabley auction for 490 guineas, a very high price at the time. He particularly esteemed this glimpse of the dawn over the English coast because it was, as Philip G. Hamerton sagaciously remarks, ''a direct return to nature and...the first decided expression on an important scale of Turner's master-passion in his art, the love of light and mystery in combination.''[95] The verticals and horizontals of the composition, the calm sea, the gently diffused light, all contribute to a sense of peace and serenity rare until this time in Turner's seascapes.

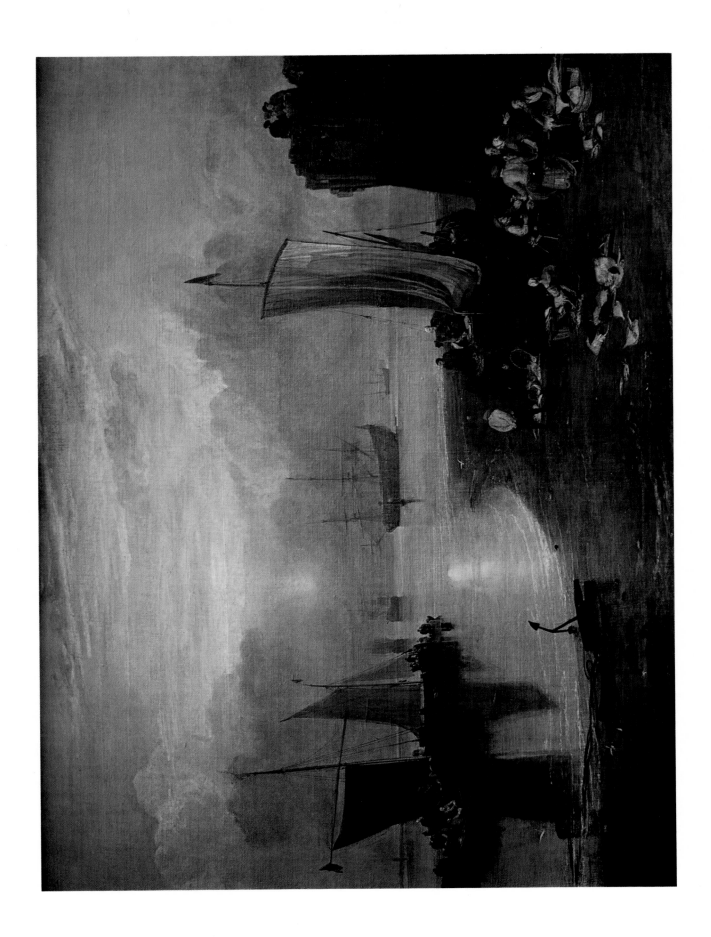

THE BATTLE OF TRAFALGAR, AS SEEN FROM THE MIZEN STARBOARD SHROUDS OF THE VICTORY

Exh. Turner's Gallery, 1806, British Institution, 1808

Oil on canvas, 67¼ x 94" (171 x 239 cm.)

Tate Gallery, London

Although Turner at the end of his life came closer to complete abstraction than any other painter of the nineteenth century, he was in his earlier work intent on the documentation of his pictures, especially his historical subjects. On December 22, 1805, the *Victory* returned to England with Nelson's body. Turner was on hand as the ship entered the Medway. A sketchbook in the British Museum shows that he carefully examined the vessel and interviewed the crew, taking notes on their appearance and uniforms. He also made a large drawing of the quarterdeck (fig. 39). He was told how Nelson was shot and how he fell on his left arm, just as sailors were carrying other wounded officers below. Captain Hardy, who held Nelson as he died, "looks rather tall...fair, about 36 years. Marshall, young...round face, proud lips." And so on about various officers and ratings.

Turner returned to London and began his painting at once. In 1806 it was exhibited partly finished in his own gallery. It was not, however, completed until 1808, when it was shown at the British Institution's third exhibition. Turner wrote out a key to the main personages, as well as a description of the immensely confused action of the British and French warships. The scene is viewed from the mizen starboard shrouds of the *Victory* at the moment Nelson has received his death wound. The Captain of the nearest French ship, the *Redoutable,* is hauling down his colors, and some of the crew are hailing for quarter. "Over her shattered stern," to quote Turner, "is the *Temeraire* engaged with...part of the French line. The *Neptune*...bearing up to engage the *Beaucentaur*...and *St. Trinidada* (seen thro' the smoke) bearing the Spanish Admiral's flag at the main. Over the Bows of the *Victory* is the *L'Intrepide*."[96] Unfortunately, the rest of Turner's description was washed away in 1928 by a flood that submerged the storerooms of the Tate Gallery.

Although Turner's *Trafalgar* was severely condemned by most critics, at least one recognized it as "a new kind of Epic picture."[97] His observation was astute, for this is one of the rare scenes of naval combat in which the viewer feels he is a participant in the main action. In most paintings of this genre, the spectator views the scene from a lifeboat, and his attention is focused on drowning sailors being pulled out of the sea. Instead, Turner has made him a part of the chaos and confusion on the flagship itself. As in Tolstoy's novel *War and Peace*, where the Battle of Borodino is described, one senses that the action is out of control, that blind, unknown forces will determine victory or defeat. There are no dramatic gestures, only a confused mass of sailors and marines, many trying to save the mainmast from falling, a few still firing at the French, others tending the wounded, but most dazed, exhausted, or dying. Turner's audience expected some evidence of heroism. There is none. Perhaps this is why the picture did not appeal to critics or the public.

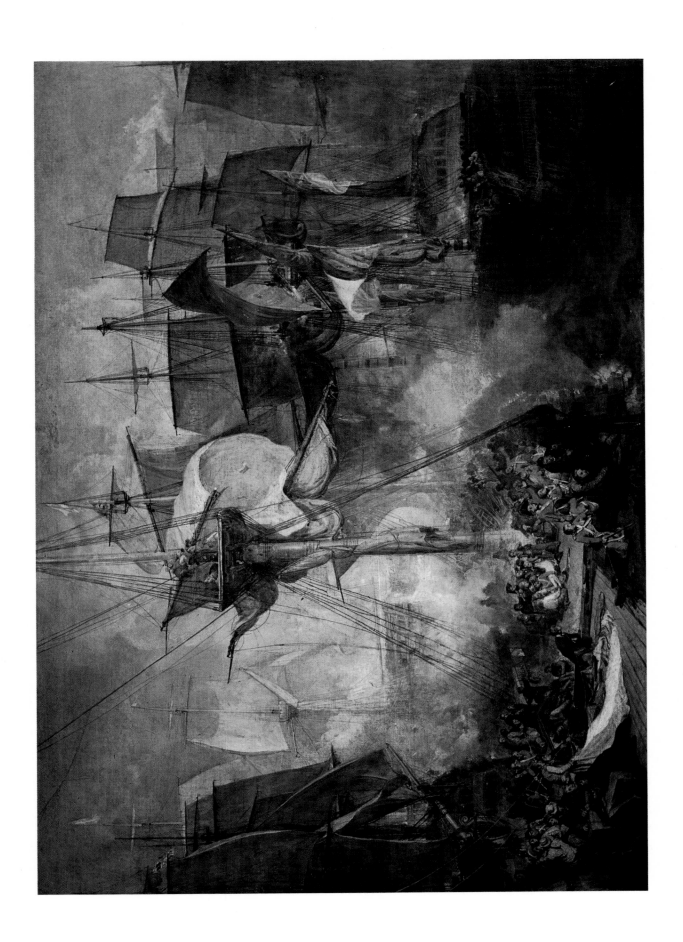

COLORPLATE 9

THE THAMES NEAR WALTON BRIDGES

c. 1811–12. Oil on panel, 14 ⅝ x 29" (37 x 73.5 cm.)

Tate Gallery, London

In the Turner Bequest were eighteen landscapes of the most exquisite beauty, painted on mahogany veneer. One of these, *The Thames Near Walton Bridges,* is dated about 1807 by Finberg.[98] Since none of the series bears any connection with exhibited canvases, they are difficult to place precisely. My own inclination is to agree with John Gage on a later dating. Gage has divided the sketches into three groups and believes them to have been executed between 1809 and 1813 or possibly even later.

When these panels were received by the National Gallery along with the rest of Turner's purloined legacy, they were not considered worthy of being inventoried. Yet they are the most beautiful oils Turner ever did directly from nature. They are also exceptional, for, apart from some sketches on prepared paper done in Devon at about the same time, the artist rarely painted out-of-doors. His usual procedure was to make only pencil drawings of scenery and to work from these later. Turner was not a plein-air artist; he preferred the studio.

These landscapes, however, viewed perhaps from a boat on the Thames or its tributary, the Wey, were done on the spot. Turner evidently wished to prove, at least to himself—since the paintings were never exhibited—that he could sketch in oil out-of-doors and depict scenery as rapidly, accurately, and beautifully as Constable, who regularly made similar sketches in the open. Surprisingly, Turner uses a palette that is rather low in key and consequently sacrifices something of the dewy freshness which makes the work of his rival so entrancing. On the other hand, though Turner is recording a direct experience of nature, each picture, as Martin Butlin and Andrew Wilton have pointed out in the catalogue of the 1975 Royal Academy Turner exhibition (no. 138), is a complete pictorial composition. By comparison, Constable's sketches seem almost casual, even haphazard. Turner was often cursory in his designs and at the end of his life was occasionally repetitious, but he arranged his pictorial elements so instinctively that even his rapid annotations of scenery are nearly always balanced and well composed.

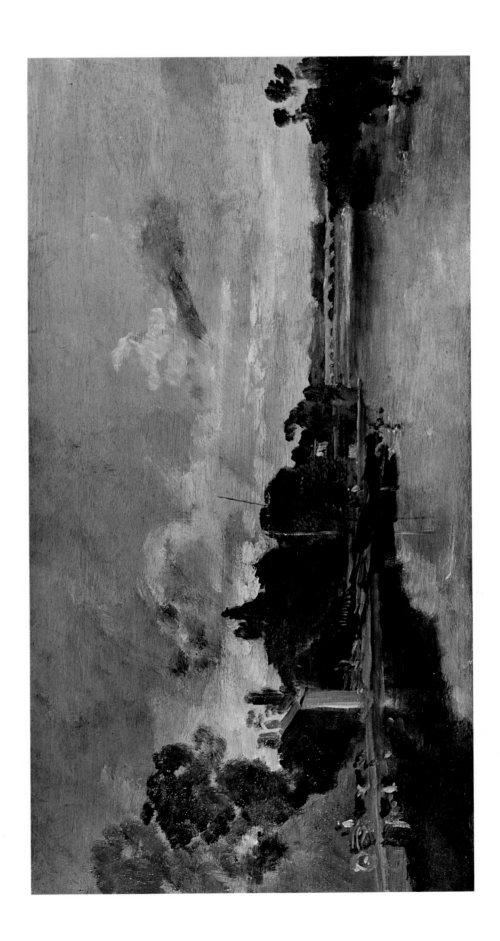

COTTAGE DESTROYED BY AN AVALANCHE

Exh. Turner's Gallery, 1810

Oil on canvas, 35½ x 47½" (90 x 120 cm.)

Tate Gallery, London

Turner's goal, to achieve heroic grandeur (a goal which Pasquin and other critics failed to discern), is strikingly evident in *Cottage Destroyed by an Avalanche*—at one time known as *The Fall of an Avalanche in the Grisons*—which he first exhibited in his own gallery in 1810. Seven years earlier Philip Jacques de Loutherbourg had painted a similar Alpine avalanche (fig. 7), and Turner, who had an intensely competitive nature, may have decided to smash the older artist's work as completely as the cottage in this picture is splintered by a tremendous boulder. One can imagine that he might have said, "This is how to depict the menace of nature. This is a theme only I have mastered."

Loutherbourg tries to convey a sense of terror through the operatic gestures of three frightened peasants, whereas Turner dispenses with human beings altogether and reveals the dreadful dynamism of nature itself. These masses of snow, ice, and rock seem to have a demonic power of destruction. Their huge scale is emphasized by the small size of the chalet, which is about to be crushed, and of the pine trees in the foreground. No human being could adequately express by gesture his reaction to Turner's cataclysmic scene. Loutherbourg paints in the idiom of the eighteenth century. His picture is no more terrifying than the last act of Mozart's *Don Giovanni*; in contrast, Turner, like Beethoven, uses every instrument in the orchestra to produce the thunderous, overwhelming impact of forces wildly out of all control.

Again, however, we come to the curious problem of Turner's insensitivity to poetry. His painting reaches the limits of art in the representation of disaster. Yet the lines (probably of his own composition) that he quotes as a parallel for his tumultuous avalanche of flying rocks and grinding ice are scarcely the verbal equivalent of his horrendous cataract.

The downward sun a parting sadness gleams,
Portenteous lurid thro' the gathering storm;
Thick drifting snow, on snow,
Till the vast weight bursts thro' the rocky barrier;
Down at once, its pine clad forests,
And towering glaciers fall, the work of ages
Crashing through all! extinction follows,
And the toil, the hope of man—o'erwhelms.[99]

These pedestrian verses perfectly illustrate Loutherbourg's picturesque avalanche, but Turner has created a totally different scene, a crashing, earthshaking tumult. Note how the paint is applied with a palette knife in bold slashing strokes. This violent handling of pigment corresponds with the violence of hurtling ice and rock. Once more Turner has reached a summit of Romantic expression.

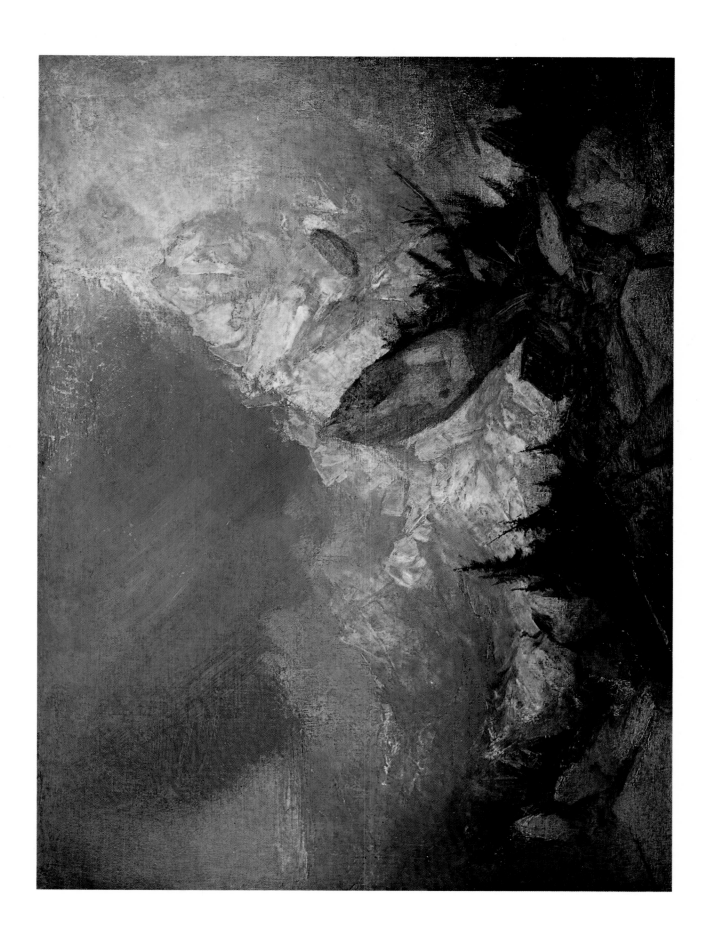

SOMER-HILL, NEAR TUNBRIDGE, THE SEAT OF W. F. WOODGATE, ESQ.

Exh. R.A. 1811. Oil on canvas, 36 x 48" (91.5 x 122 cm.)

National Gallery of Scotland, Edinburgh

To understand Turner, it is important to preceive how he differs from his greatest rival, Constable. *Somer-Hill, Near Tunbridge,* which Turner exhibited at the Royal Academy in 1811, and *Wivenhoe Park* (fig. 13), which Constable showed in 1816, illustrate some of these differences. Turner's picture was probably commissioned by William Francis Woodgate, who, on the death of his father in 1809, inherited Somer-Hill along with £ 300,000. Although within a few years Woodgate had lost most of his money and had to sell his estate, he was for a time very rich; and being proud of his mansion, a good example of Jacobean architecture, doubtless wished to have it portrayed. Wivenhoe was a more modest residence, built in the Georgian style by Gen. Frank Slater Rebow over a century later. Both houses are still occupied.

In looking at the painting *Wivenhoe Park*, one is immediately struck by the wide angle of vision. The explanation is that General Rebow told Constable that his landscape showed too little of the estate. To overcome this criticism, the painter had to add strips of canvas on either side, thus enlarging the view. In the end "it comprehended too many degrees."[100] This flaw Constable admitted, but at the time he was poor and struggling to please. By contrast, Turner, already successful, and more indifferent to the wishes of his patron, included much less of the park. Viewing Somer-Hill at a normal angle, he was able to blend water, trees, and meadows into a single image, which the eye can apprehend without a change of focus. Constable's picture by comparison seems spotty. It lacks that all-enveloping light which he was later to attain but which was from the beginning so conspicuous a part of Turner's style. Constable's dappled sunshine is attractive, his clouds decorative, the reflections in the water truly observed; but in his slow development as a painter he still views the scene bit by bit rather than looking at it as a whole, as Turner has.

Both artists were masterful painters of skies. Turner told Effie Millais that he would spend hours on end lying in a boat looking up at the clouds until they were forever fixed in his memory. Constable also made many cloud studies, but these he did at a later period in his life. When he painted *Wivenhoe Park*, his observation of the sky was still limited, and he combined cumuli artificially to make a striking pattern. Turner, with his exceptional precociousness, mastered the formation of clouds at a much earlier age. In technical proficiency and the ability to convey what he saw, he matured far more rapidly than Constable. When he came to paint the sky in *Somer-Hill* the effect is reality itself.

But Turner was not above artifice. He would never have agreed with Constable that "Nature...constantly presents us with compositions of her own, far more beautiful than the happiest arranged by human skill."[101] When Turner began sketching at Somer-Hill, he realized that the lake was too far from the house. Therefore, he moved it closer. He wanted the mansion reflected in a sheet of water, and although a quarter of a mile of pasture actually separates the lake and the mansion, reflected it is. Constable would never have violated a visual fact so arbitrarily. His painting is a brilliant prose description of the very essence of English scenery. Turner's is the poetic image of a country estate, a vision of a house and park, which at any moment, one feels, may vanish like a dream of tranquillity and happiness.

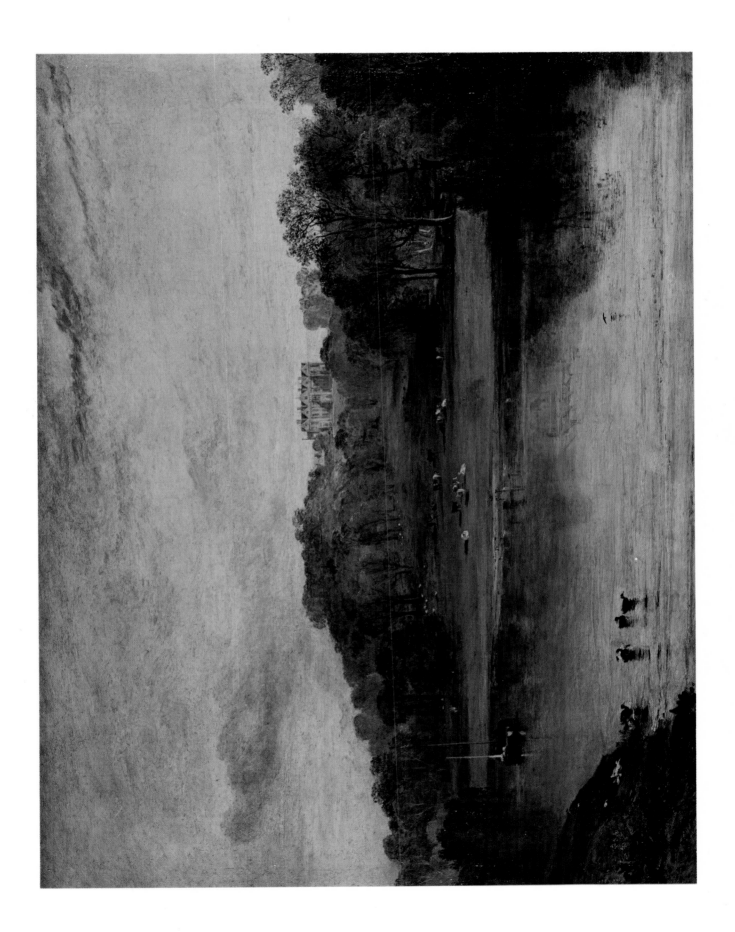

SNOW STORM:

HANNIBAL AND HIS ARMY CROSSING THE ALPS

Exh. R.A. 1812. Oil on canvas, 57 x 93" (145 x 236.5 cm.)

Tate Gallery, London

Turner was forever scribbling mediocre verse. In the stanza he attached to *Hannibal Crossing the Alps* there are, however, two inspired lines:

While the fierce archer of the downward year
Stains Italy's blanch'd barrier with storms.[102]

Since Sagittarius, the archer, enters the heavens in November, the poet adroitly and correctly places the crossing of the Alps in the autumn. (It was actually completed during October, in 218 B.C.) Hannibal's triumph, infelicitously described in the rest of Turner's poem, is supremely conveyed in his painting. A great storm sweeps across the mountains. Hannibal, minute in scale, seated on an elephant in the center of the middle distance, looks down on distant Italy. The foreground is a scene of plunder, rape, and slaughter. For Turner, like his older contemporary Goya, recognized these as being part of "the disasters of war."

This work is the first example of Turner's extraordinary innovation in composition, the design being based not on the traditional horizontals, verticals, and diagonals but on irregular, intersecting arcs. A vortex of cloud and mist seems to suck the eye into vast distances until one's vision finally rests on the sunlit Italian plains, the Carthaginian goal. These cones of light and shade appear from this time on in Turner's works, and in scale and grandeur are without precedent in art.

Although *Hannibal Crossing the Alps* may have been inspired by John Robert Cozens's lone painting in oil of the same subject, now lost, which Turner said he had carefully studied, the inspiration for the storm itself was actual observation. From Thornbury we learn that in 1810, while Turner was staying with Walter Fawkes in Yorkshire, the painter called Fawkes's son Hawkesworth out of the house to watch immense thunderclouds roll over the Chevin and the Wharfe valley. Turner was using the back of a letter to sketch and make notes on the appearance of the storm. In Hawkesworth's words, "I proposed some better drawing block, but he said it did very well. He was absorbed—he was entranced....Presently the storm passed, and he finished. 'There,' said he, 'Hawkey; in two years you will see this again, and call it Hannibal Crossing the Alps!' "[103] Turner did as he had predicted, and two years later, in 1812, sent the painting to the Royal Academy.

Few of the spectators who came to see the exhibition realized that Turner considered his canvas a warning to Britain. He felt a connection between the fate of Carthage and the possible defeat of England in the Napoleonic wars. Rome had triumphed and so might France. Napoleon himself had written: "Europe watches / France arms / History writes / Rome destroyed Carthage." Luckily for England, however, Napoleon, lacking the wisdom of Scipio Africanus in his struggle with Hannibal, failed to concentrate his forces against his major antagonist, and Turner's gloomy forebodings went unfulfilled.

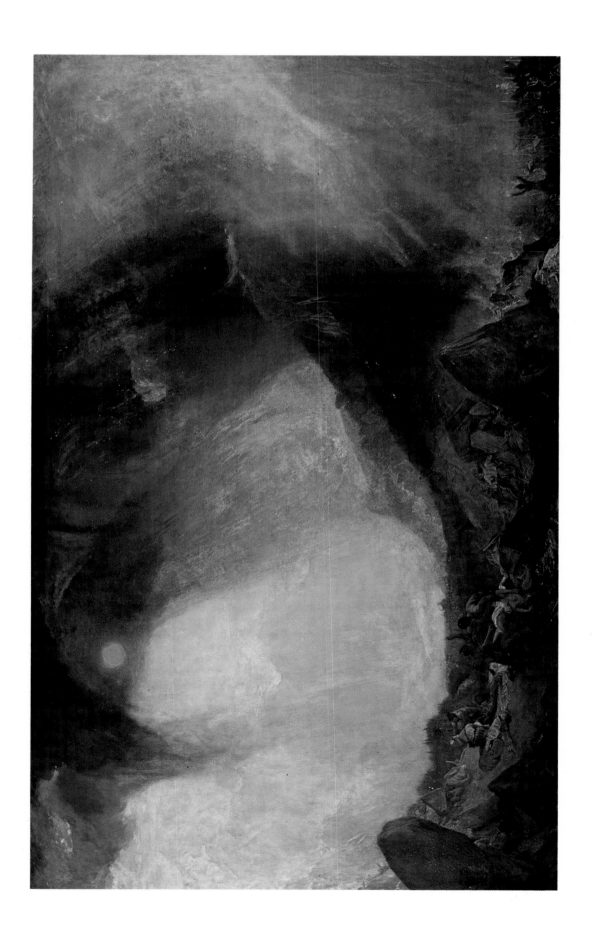

DIDO BUILDING CARTHAGE,
OR THE RISE OF THE CARTHAGINIAN EMPIRE

Exh. R.A. 1815. Oil on canvas, 61¼ x 91¼" (155.5 x 232 cm.)

National Gallery, London

In 1815 Turner exhibited at the Royal Academy two of his most famous pictures: *Dido Building Carthage* and *Crossing the Brook* (colorplate 14). Both were enthusiastically received. A critic said of the former that it "is one of the sublime achievements which will stand unrivalled."[104] Turner agreed! And to prove the correctness of this judgment, in his will he left the painting to the National Gallery on the condition that it be hung beside Claude's *Seaport* (fig. 34), which he considered its only possible rival. The journalist and poet Alaric Watts told how he went to Turner's studio with J. O. Robinson, who intended to buy *Dido Building Carthage* to have it engraved as a pendant to Turner's *Temple of Jupiter*.[105] The price placed on the picture a few days earlier had been 750 guineas, and Turner had raised this to 1,000 guineas. They left to consider the increase, but Turner soon sent them a message "declining to dispose of it at all; he considered it, he said, his *chef d'oeuvre*."

Watts added that Turner subsequently refused 5,000 guineas offered for the picture "by a party of gentlemen anxious to purchase it for the purpose of presenting it to the National Gallery." It is true that Turner had by then willed *Dido Building Carthage* to the nation, but he might easily have canceled his bequest with a codicil. Turner may have been avaricious, but his pride was stronger than his desire for money. He wished to be the donor of the painting himself, so that he could insist on his harbor scene being hung in a location to outshine Claude's *Seaport*.

As a youth Turner had once burst into tears on seeing it, "because," as he confided to a fellow artist, "I shall never be able to paint anything like that picture."[106] In spite of his youthful pessimism, he has, in my opinion, surpassed this work by Claude, one of the greatest seventeenth-century landscapes. Turner's canvas is more complex, richer in its abundance of detail, with a wider range of tones. By comparison *Seaport* seems pallid and somewhat oversimplified. Also, Turner makes the spectator more a part of the scene. The water comes to the picture plane, and consequently the viewer feels as though he were sailing from deep within the harbor on an unseen vessel. Claude, by contrast, erects a barrier of shore across the foreground, and the spectator remains outside the picture. Turner achieves greater unity by basing his composition on two diagonals leading the eye into the picture space, like converging perspective lines, whereas Claude uses one diagonal which he crosscuts with boats and figures, thereby diminishing a certain compositional coalescence. But Turner has not every advantage. The sunlight in his picture is more diffuse than it is in Claude's, and this golden haze blocks the distance. In Claude's painting, the spectator has the sensation of gliding into infinite space, and in so doing of attaining a psychological release experienced and remarked on by both Nietzsche and Dostoevski when looking at landscapes by this artist—an emotion less often felt in viewing Turner's canvases.

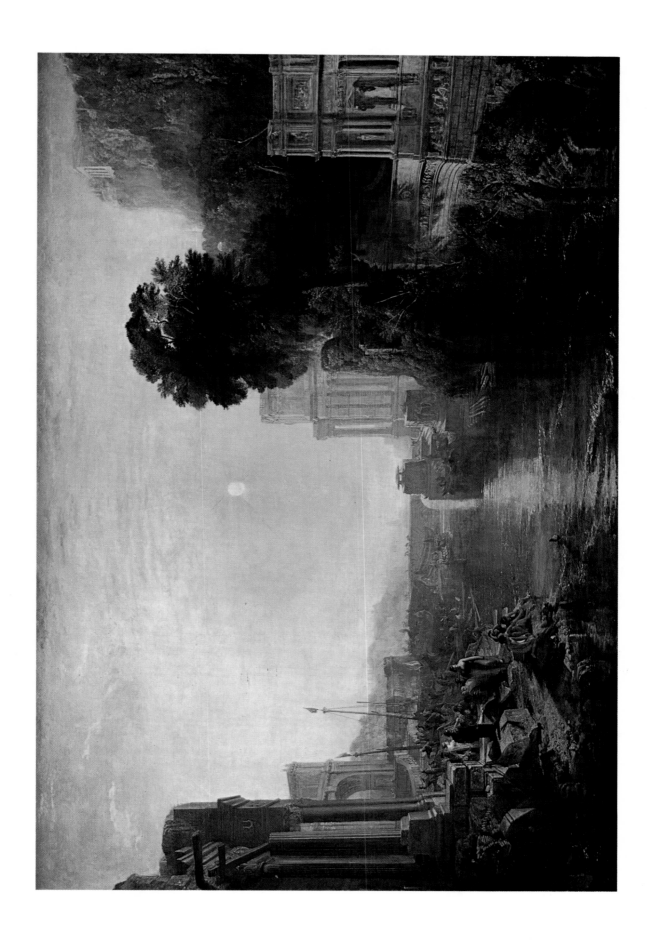

CROSSING THE BROOK

Exh. R.A. 1815, Turner's Gallery, 1835

Oil on canvas, 76 x 65" (193 x 165 cm.)

Tate Gallery, London

In 1815 Turner sent to the Academy *Crossing the Brook,* one of the most perfect landscapes ever painted, and one that, along with *Dido Building Carthage,* climaxed the first half of his career. *Crossing the Brook* is based on sketches made in Devonshire, but the artist has applied to this English scene the Claudian formula of darks crowded in the foreground, with trees on either side, and beyond the middle distance a declivity and then a sweep of space. The girl who has just waded across the brook is said to be Evelina Danby, the painter's illegitimate daughter, while the girl who kneels on the bank in a patch of sunlight is thought to be her sister Georgiana. The girl thought to be Evelina also appears in a picture exhibited at the Academy two years earlier, *Frosty Morning* (fig. 19), one of Turner's masterpieces. This work is so monochromatic compared to the artist's other work that I have had it reproduced in black and white.

The modulations of tone which render the aerial perspective of *Crossing the Brook* are exquisitely handled, but William Hazlitt was critical of Turner's ability. In an essay written in 1816,[107] he carpingly accuses the painter of not representing ''the objects of nature but the medium through which they were seen.'' This is a criticism which can be applied equally to Claude, in whose landscapes all forms in the remote distance are dissolved into the same bluish gray mist. Hazlitt's essay ends with the famous phrase ''pictures of nothing and very like.'' No painting by Turner in the first half of his career justifies this memorable description; yet it can be applied to scores of paintings done at the end of his life. Thus Hazlitt shows himself a critic with extrasensory perception, for he anticipates work the artist will subsequently do to make his criticism valid!

The unanimity of praise from other critics was surprising, but no approbation came from Sir George Beaumont, whose influence with his peers, his fellow collectors, was much greater than that of any scribbler for the press. He was determined to prevent Turner selling his pictures. He told Farington that ''*Crossing the Brook* appeared to him *weak* and like the work of an old man, one who no longer saw or felt colour properly; it was all of *pea-green* insipidity.''[108] Sir George was looked upon as the oracle of the connoisseurs; and whereas Turner in the past might have painted a dozen pictures in the year and sold more than half, his enemy's attacks now made this impossible. As a writer in the *Athenaeum* said, ''One poetic composition will make a name to a painter, but twenty will not find him subsistence; he has to seek his daily bread from more homely sources. Turner, the noblest landscape painter of any age, cannot sell one of his poetic pictures: he rolls them up, and lays them aside after they have been the wonder of the Exhibition.''[109]

Once the pictures were back in his studio, Turner disliked looking at them. He admitted to William Kingsley[110] that ''the realization was always immeasurably below the conception.'' And when Kingsley pointed out that paint was flaking from *Crossing the Brook* he answered, ''What does it matter. The only use of the thing is to recall the impression.''

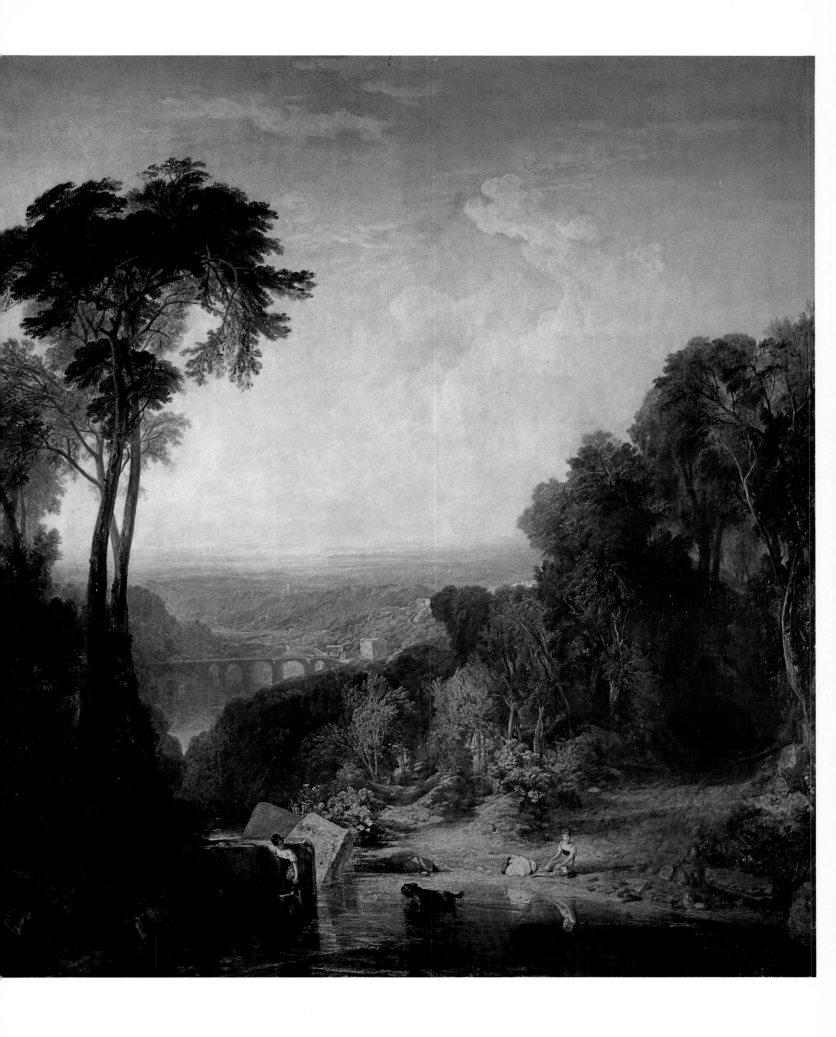

DORT OR DORDRECHT: THE DORT
PACKET-BOAT FROM ROTTERDAM BECALMED

Exh. R.A. 1818. Oil on canvas, 62 x 92" (157.5 x 233.5 cm.)

Yale Center for British Art New Haven Paul Mellon Collection

In 1818, the exhibition in the Academy was arranged by John Jackson, Sir Augustus Wall Callcott, and John Flaxman. When the *Dort* arrived, Callcott removed his own picture from the place of honor and hung instead Turner's masterpiece. The impact of the *Dort* was extraordinary. Until then no marine had been painted in so high a key of color nor had so dazzling a work appeared on the walls of the Academy. James Thomson told Farington that "the picture was so brilliant it almost put your eyes out."[111] We are now used to colors of far greater intensity—Turner himself provided many examples later in life—but in 1818, compared to the other paintings in the exhibition, the *Dort* must have seemed astounding. The critic of the *Morning Chronicle* called it "one of the most magnificent pictures ever exhibited,"[112] and Constable many years later told C. R. Leslie, his biographer, that he remembered it as "the most complete work of genius I ever saw."[113] During the exhibition Walter Fawkes bought the painting for 500 guineas, and until it was purchased by Paul Mellon it hung in Farnley Hall in Yorkshire, surrounded at one time by more of Turner's works than were to be found in any other private collection.

The *Dort* has come down to us in seemingly perfect condition, a rarity among Turner's paintings. The tragedy of deterioration, far too prevalent in his work, must always depress a Turner lover. It infuriated Ruskin, who wrote indignantly, "The fact of his using means so imperfect, together with that of his utter neglect of the pictures in his own gallery, are a phenomenon in human mind which appears to me utterly inexplicable; and both are without excuse."[114] But in the *Dort* the technique is flawless. Here Turner has avoided his major error, painting over wet pigment, and has instead allowed the colors to dry thoroughly before blending and mingling others with them. Also, immediate purchase saved the picture from the blight of Turner's house, with its dampness and mildew, its miserable leaks. But, most fortunately of all, the *Dort* escaped what Ruskin classified as "the greatest foes of Turner...the sun, the picture cleaner, and the mounter."[115]

In 1851 Ruskin journeyed to Farnley to see the collection. He was disappointed in the *Dort*, judging it to be "very fine in distant effect—but a mere amplification of Cuyp."[116] Though an undoubted challenge to Aelbert Cuyp, it is certainly more than "a mere amplification." Cuyp could never have managed the vast expanse of sky glowing with light, the beautiful reflections in the water, the luminous atmosphere created by perfect gradations of tone. This is a painting which makes the eye joyfully drink in the radiance and the stillness of a summer evening. It conveys an emotion that sometimes follows a long day at sea when, at anchor in the shelter of a harbor, one experiences a refreshment of spirit and a sense of the beneficent glory of nature.

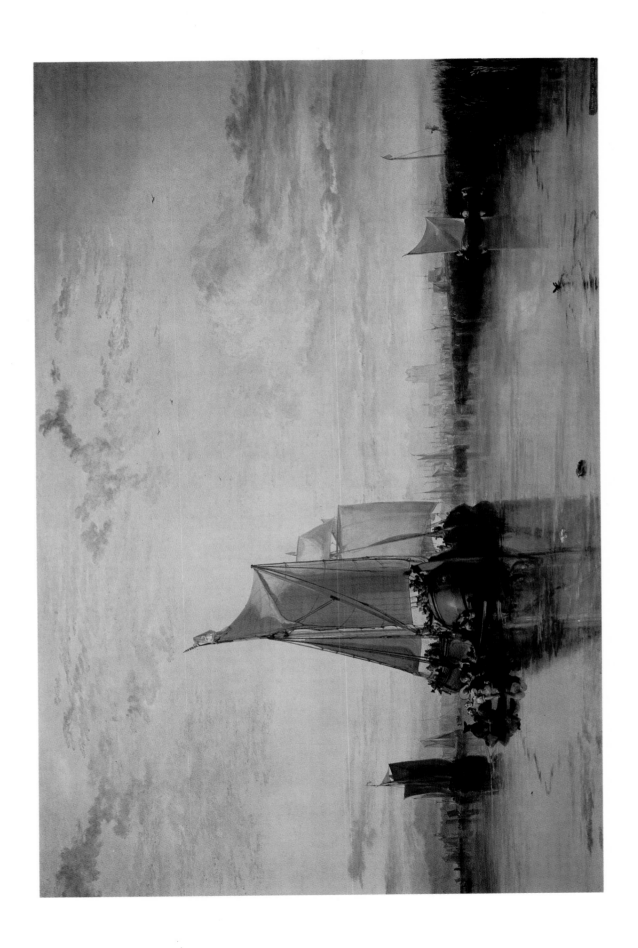

COLOGNE:
ARRIVAL OF A PACKET-BOAT: EVENING.

Exh. R.A. 1826. Oil on canvas, 59 x 89" (150 x 225 cm.)

Copyright the Frick Collection, New York

In the commentary on colorplate 21 the reader will find an anecdote told by Leslie of how Turner brightened his picture of Helvoetsluys on Varnishing Day so that it would outshine that of his rival, John Constable. To be fair, one should also point out that Turner, to please a colleague, once toned down a picture, the view of Cologne reproduced opposite. When shown at the Royal Academy, the painting was hung between two of Sir Thomas Lawrence's portraits, and, as Ruskin said, "The sky of Turner's picture was exceedingly bright, but it had a most injurious effect on the color of the two portraits. Lawrence naturally felt mortified, and complained openly of the position of his pictures. . . . On the morning of the opening of the exhibition, at a private view, a friend of Turner's who had seen the Cologne in all its splendour, led a group of expectant critics up to the picture. He started back from it in consternation. The golden sky had changed to a dun color. He ran up to Turner, who was in another part of the room. 'Turner, *what* have you been doing to your picture?' 'Oh,' muttered Turner in a low voice, 'poor Lawrence was so unhappy. It's only lamp-black. It'll wash off after the exhibition!' He had actually passed a wash of lamp-black in watercolor over the whole sky, and utterly spoiled his picture for the time, and so left it through the exhibition, lest it should hurt Lawrence's."[117]

The next year, 1827, *Cologne* seems to have had a potential buyer. This led to the artist's writing a letter to his father—one of the few letters between the two which has been preserved. He directed "Old Dad," his factotum, that "Mr. Broadhurst is to have the Picture of Cologne, but you must not by any means wet it, for all the Colour will come off. It must go as it is—and tell Mr. Pearse, who is to call for it, and I suppose the Frame, that it must not be touched with Water or Varnish (only wiped with a silk handkerchief) until I return, and so he must tell Mr. Broadhurst."[118]

The letter shows Turner's anxiety about the effect of moisture on his paintings. Eastlake told Thornbury that he had advised Turner to have the cases of his pictures being shipped from Rome covered with wax cloth, "as the pictures without it might be exposed to wet. Turner thanked me and said the advice was important; 'for,' he added, 'if any wet gets to them, they will be destroyed.' This indicates his practise of preparing his pictures with a kind of tempera, a method which, before the surface was varnished, was not waterproof."[119]

Yet Turner, after the Royal Academy Exhibition, washed off the lampblack on his *Cologne*. Evidently he knew his own technique so well that he could do what he would trust no one else to attempt.

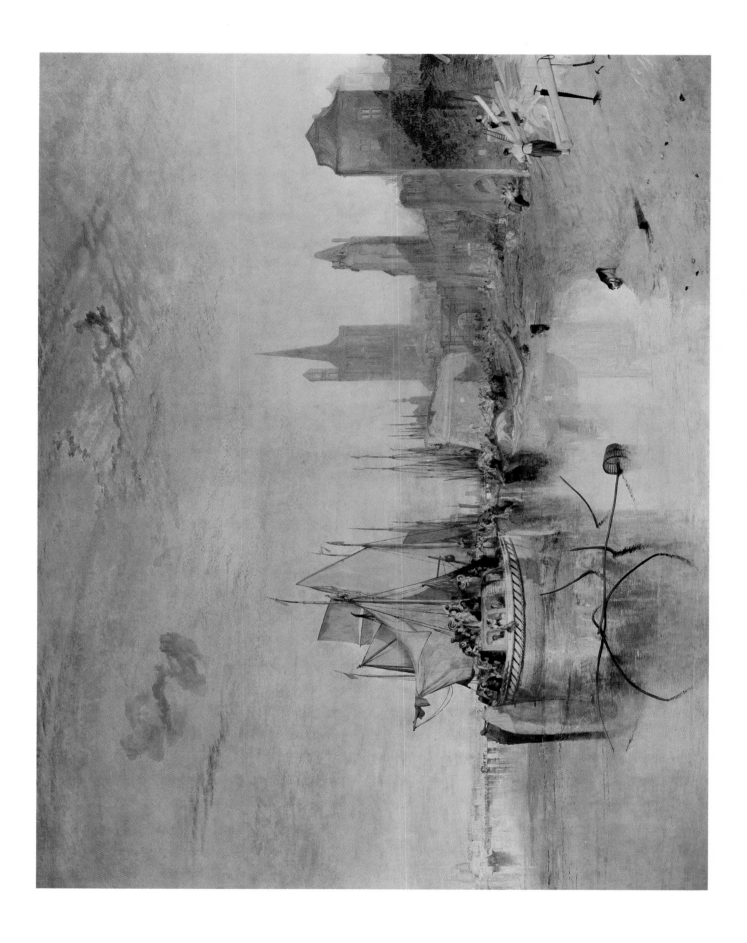

MORTLAKE TERRACE

Exh. R.A. 1827. Oil on canvas, 36¼ x 48⅛" (92.1 x 122.2 cm.)

National Gallery of Art, Washington, D.C.

Andrew W. Mellon Collection

Turner found the terrace of a residence at Mortlake, not far from the house he built at Twickenham, a delightful place on which to sit and paint. He did two pictures of the Thames embankment bordering the "Seat of William Moffatt," one in the early morning facing toward the house (fig. 26) and the other, here reproduced, at sunset, facing in the opposite direction. Both paintings were shown at the Royal Academy, the first in 1826, this one a year later. In these paintings the topographical exactitude of the artist's early work has vanished. Turner reveals instead the major interest of the second half of his life: light and the visible atmosphere. These concerns were, at a later date, also the preoccupation of the Impressionists, but there is an important difference. Monet, for example, would have painted Moffatt's house at different hours but from the same position, noting all the changes in color resulting from changes in illumination. Turner, however, turned his easel around to paint two views, from east and west. Thus he faced the sun, rising and setting. He had little interest in a scientific observation of different intensities and angles of light. His effort was concentrated on rendering the atmospheric envelope of the scene: the cool, dewy appearance, with moisture drying on the ground, characteristic of the first hours of a summer morning, and the warm diffused glow of the late afternoon when the sun throws long shadows across the lawn.

The peculiar luminosity of morning and afternoon were not, however, appreciated by contemporary critics, and the picture reproduced here in particular was abused for its excessive yellowness. Though doubtless hurt by such criticism, Turner joked about it in a letter, saying that he must not describe a companion's complexion as yellow, "for I have taken it *all* to my keeping this year, so they say. And so I meant it should be."[120] And he was right, for if one looks directly into the sinking sun on a hot afternoon, the misty air turns to a golden haze, just as Turner has depicted it.

Turner's absorption in the rendering of light, however, occasionally caused him to be careless about the design of his paintings. This is illustrated by an anecdote recorded by Frederick Goodall, whose father engraved some of Turner's paintings. While Turner was lunching, after having worked all morning on Varnishing Day, Edwin Landseer came into the exhibition gallery and noticed that the picture reproduced opposite needed an accent in the center to focus the composition. He cut out of paper the silhouette of a little dog and stuck it on the parapet. "When Turner returned," Goodall says, "he went up to the picture quite unconcernedly ... adjusted the little dog perfectly, and then varnished the paper and began painting it. And there it is to the present day."[121] It is indeed, and when I was director of the National Gallery of Art I refused to have the picture cleaned for fear of removing the paper dog.

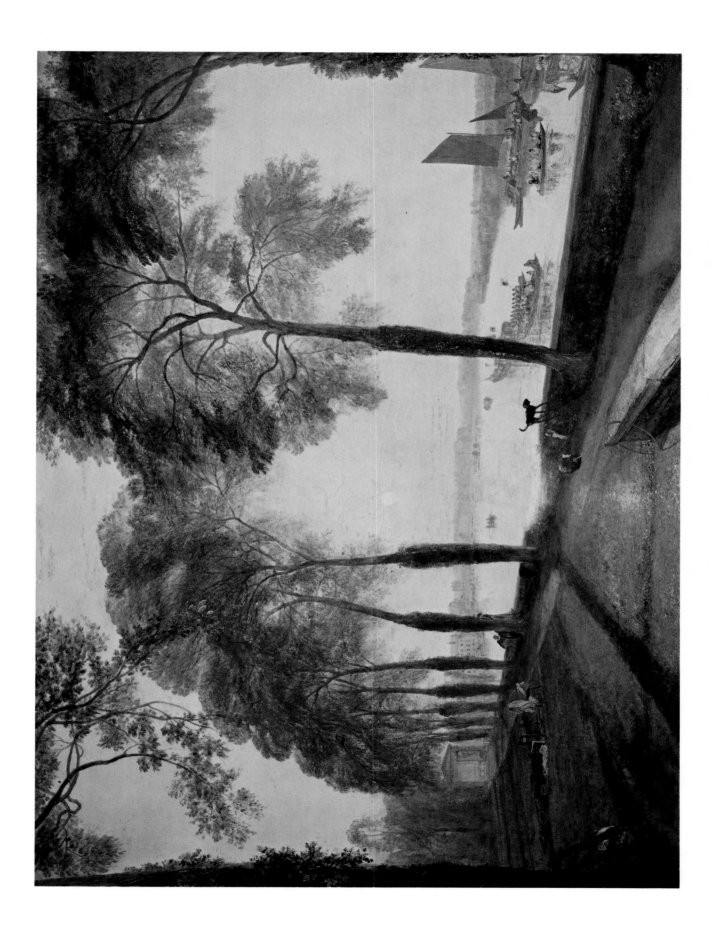

ULYSSES DERIDING POLYPHEMUS— HOMER'S ODYSSEY

Exh. R.A. 1829. Oil on canvas, 52¼ x 80½" (132.5 x 203 cm.)

National Gallery, London

Turner was always intellectually ambitious and deeply interested in literature. He was so fascinated by the *Odyssey* that he wanted to read it in the original, and he made a compact with his friend the Reverend H. S. Trimmer to give the minister lessons in painting in exchange for lessons in Greek. The clergyman made progress; Turner made none. He found he was better as a pedagogue than as a scholar, and he soon gave up his studies. There were plenty of translations of Homer, however, and for this picture, which he showed at the Royal Academy in 1829, he turned to Alexander Pope.

The subject, a moment of high tragedy, is suited to Turner's search for the sublime. Ulysses has just escaped from a night of terror in the cave of the giant Polyphemus, whom he has blinded and whose huge form can be seen on the summit of the mountainous Sicilian promontory. The hero, standing on the prow of his ship, holds aloft a torch, taunting his enemy; his followers, from the rigging of their fanciful vessel, joyfully watch their victim contorted in agony. On the right the rest of the Greek fleet, prow to prow, enframes the scene.

Nereids, with stars on their foreheads, swim playfully around Ulysses' ship. Their pale, iridescent tones suggest, as John Gage has observed, the phosphorescence often to be noted as a boat moves through the sea, especially in warm latitudes.[122] This was a phenomenon commented on by contemporary writers like Erasmus Darwin and Joseph Priestly, and Turner has added to the Homeric legend his own allegorical gloss on eighteenth-century scientific observation.

The sky, too, one of the most beautiful ever painted, had its own reference to Greek mythology. According to Ruskin, horses, still faintly visible, were originally a conspicuous part of the sunbeams that fan across the heavens. They were "drawn in fiery outline, leaping up into the sky and shaking their crests out into flashes of scarlet cloud."[123] These chargers are evidence of Turner's intellectual curiosity. They were inspired by the Horses of the Dawn, which he had come across while looking through James Stuart and Nicholas Revett's drawings of the east pediment of the Parthenon. Alas, cleaning has virtually obliterated this charming poetic conceit.

But the supremely beautiful color remains. Turner has learned from his studies in Italy how to attain a tonal richness that makes his earlier work seem pale by comparison. Such chromatic resonance, based on a play of warm and cool tones, here essentially the azure of the sea against the gold of the ships, repeated, though less intensely, in the sun, clouds, and sky, is characteristic of many of his late paintings. Ruskin rightly said, "*Polyphemus* asserts his perfect power and is, therefore, to be considered as the *central picture* in Turner's career."[124]

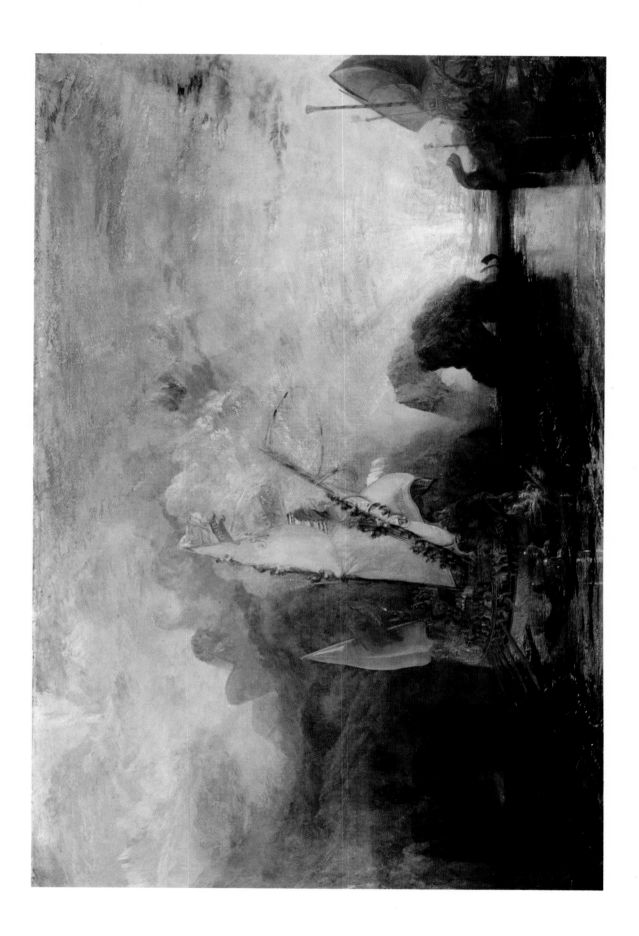

PETWORTH PARK:

TILLINGTON CHURCH IN THE DISTANCE

c. 1828. Sketch, oil on canvas, 25⅜ x 57⅜" (64.5 x 145.5 cm.)

Tate Gallery, London

The hospitality of Petworth, which Turner had enjoyed intermittently for some years, became particularly welcome on the death of his father, which had left him solitary and despairing. He was taken in by Lord Egremont and given a studio. He spent weeks on end wandering in the park, which he loved to paint. He fished; he sketched; he did little intimate watercolors of the guests; and he produced several of his finest pictures.

Lord Egremont wanted four landscape canvases to hang under full-length portraits in his magnificent Carved Room; and Turner welcomed the commission, completing at least two pictures, as a recently discovered letter indicates, as early as 1828. He provided paintings of unusual shape, long rectangles to fit the spaces to be filled. The studies for these works, now in the Tate Gallery, show how, in the final versions, Turner had to suppress his instinctive originality to please Lord Egremont's conventional artistic taste, the earl's sole concession to conventionality. For example, this picture, the first version of *Petworth Park,* is composed in a manner which must have shocked Turner's patron. How startling it must have been to a connoisseur like Lord Egremont to find everything curving away from the spectator! He saw a picture that violated all accepted compositional principles, a painting designed on the basis of an ellipse corresponding to the ellipse of actual vision. Turner skillfully places the viewer within this oval of terrace and sky, drawing him into the scene by the diagonal of the dogs running toward their master; but this was not at all what Lord Egremont wanted in a landscape of his park. The final version painted for Petworth and still there (fig. 29) omits the terrace, and the design is the usual series of parallel planes connected by diagonals.

But more unacceptable than the composition of the preliminary painting must have been the mood it conveyed: its mysterious sense of loneliness. The empty chair, the curtain blown through the window in the left-hand corner, the blue and white china jar, all indicate that someone has been seated on the terrace, doubtless the man walking toward his dogs. There is something inevitably moving about a solitary figure silhouetted against the sun as it sinks below the horizon. The image of death is educed, though under this resplendent sky, radiant with reflected light, the recognition of mortality comes serenely, almost happily. This peaceful park will long outlast the old man, presumably Lord Egremont, who is returning to his house in the gathering twilight. The dogs running to greet their master are a foil to the stillness of the deer, whose long shadows point toward the vacant terrace. Soon the park itself will be empty save for these grazing stags and does.

A few years later, in 1837, Lord Egremont died. Turner, followed by other artists, walked before the hearse. His sketch of Petworth Park had presaged the dissolution of a companionship which for a time gave him the happiness he was granted so rarely.

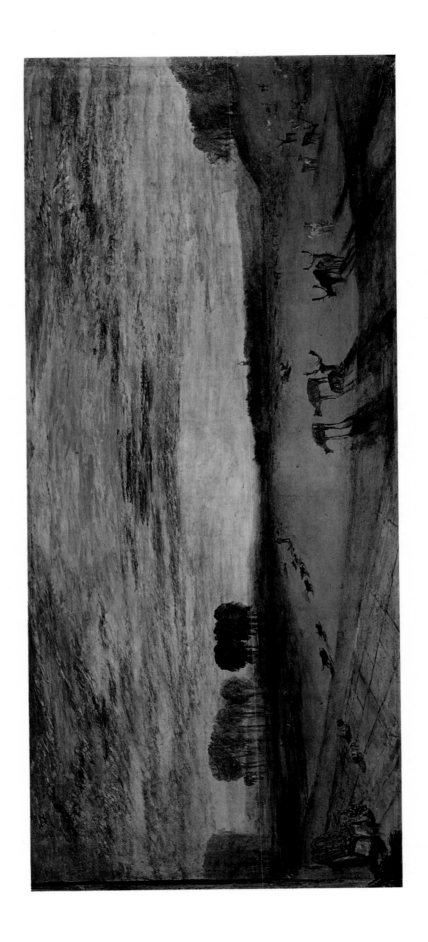

STAFFA, FINGAL'S CAVE

Exh. R.A. 1832. Oil on canvas, 36 x 48" (91.5 x 122 cm.)

Private Collection

In 1831 Turner reluctantly agreed to do the illustrations for a collected edition of the poetry of Sir Walter Scott. Though the "Man of Art," as Scott called him, hoped to be able to use enough drawings he had previously made to avoid the trip north, the publisher and the author insisted that he visit a number of the places mentioned in the poems. It was on this trip to Scotland that Turner sailed to the island of Staffa on the west coast. The weather was bad, and in a letter Turner wrote that as their steamship was passing the island, "the sun getting toward the horizon, burst through the rain-cloud, angry, and for wind; and so it proved, for we were driven for shelter into Loch Ulver."[125]

He has depicted his steamer on this wild and turbulent sea, with the sun about to set. A more perfect expression of the Romantic spirit is difficult to conceive. The threatening storm, the towering cliffs, the turbulent waves, the haloed sun, all convey a mood of foreboding, a sense of impending tragedy.

The painting was shown at the Royal Academy in 1832 and was generally admired, but it remained in Turner's gallery until 1845. Then it was bought by an American collector, James Lenox, on the advice of C. R. Leslie. Leslie has described purchasing the picture from Turner.

Mr. Lenox expressed his willingness to give five hundred pounds and left the choice to me. I called on Turner, and asked if he would let a picture go to America. "No; they won't come up to the scratch." [This was an allusion to an experience he had recently had with another American.] I told him a friend of mine would give five hundred pounds for anything he would part with. His countenance brightened, and he said at once " He may have that, or that, or that." ... I chose a sunset view of Staffa.... When it reached New York, Mr. Lenox was out of town, and we were in suspense some time about its reception. About a fortnight after its arrival he returned to New York, but only for an hour, and wrote to me, after a first hasty glance, to express his great disappointment. He said he could almost fancy the picture had sustained some damage on the voyage, it appeared to him so indistinct through-out.... For the present he could not write to Mr. Turner, as he could only state his present impression.

Unfortunately I met Turner, at the Academy, a night or two after... and he asked if I had heard from Mr. Lenox. I was obliged to say yes. "Well, and how does he like the picture?" "He thinks it indistinct." "You should tell him," he replied, "that indistinctness is my forte."[126]

In the end Lenox came to admire the picture greatly and left it to the New York Public Library, whence it was sold and returned to England, thus depriving America of one of its greatest works by Turner.

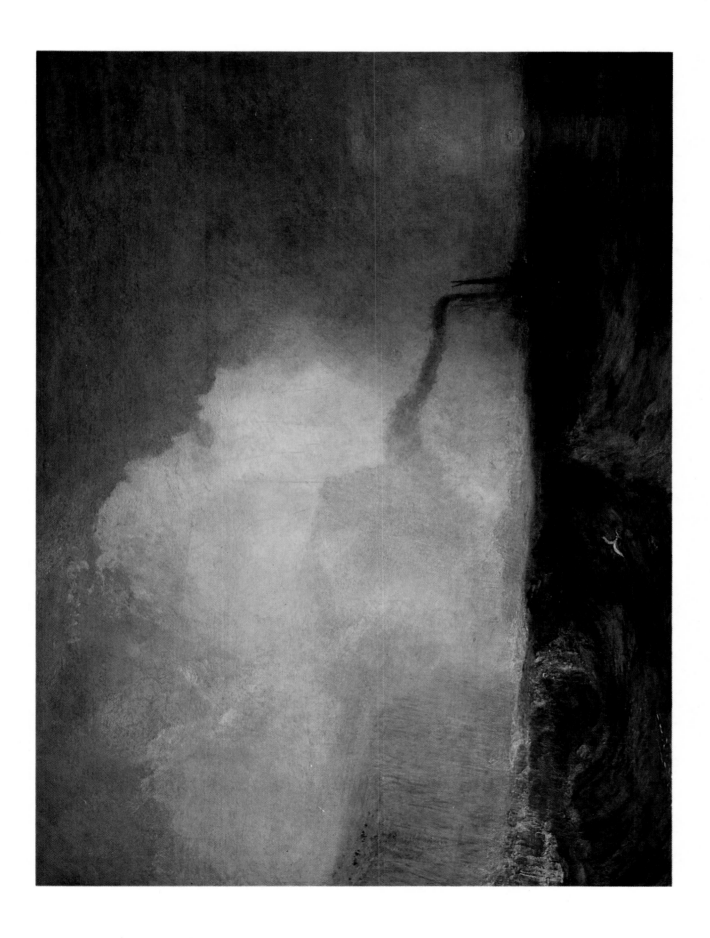

HELVOETSLUYS—
THE "CITY OF UTRECHT", 64, GOING TO SEA

Exh. R.A. 1832. Oil on canvas, 37 x 45" (90 x 120 cm.)

Private Collection

The quotations accompanying this reproduction and the one following describe the peculiar method of painting Turner developed in later life. In 1809 Joseph Farington persuaded the members of the Royal Academy to establish "Varnishing Days," a period just before the opening of the annual exhibition when they could freshly varnish their pictures and apply any final touches they might wish. The time permitted for these last-minute furbishings was gradually extended to five days. Several efforts were made to abolish this privilege on the grounds that it was granted only to Academicians, but Turner successfully opposed all reforms. He had come to depend more and more on the opportunity to finish his pictures after they were hung, when he could see where they were to be shown. But completing pictures already installed meant haste, and often the successive layers of paint which were applied with such speed dried unevenly. As a consequence, many of his canvases have not lasted well. Painting up to the last minute, however, while militating against permanence, was effective with competitors, as the following quotation from C. R. Leslie's *Autobiographical Recollections* indicates.

In 1832, when Constable exhibited his *Opening of Waterloo Bridge*, it was placed in the school of painting—one of the small rooms at Somerset House. A seapiece [*Helvoetsluys—The "City of Utrecht"*], by Turner, was next to it—a grey picture, beautiful and true, but with no positive colour in any part of it. Constable's *Waterloo* seemed as if painted with liquid gold and silver, and Turner came several times into the room while he was heightening with vermillion and lake the decorations and flags of the city barges. Turner stood behind him, looking from the *Waterloo* to his own picture, and at last brought his palette from the great room where he was touching another picture *(Childe Harold)*, and putting a round daub of red lead, somewhat bigger than a shilling, on his grey sea, went away without saying a word. The intensity of the red lead, made more vivid by the coolness of his picture, caused even the vermillion and lake of Constable to look weak. I came into the room just as Turner left it. "He has been here," said Constable, "and fired a gun." On the opposite wall was a picture by Jones, of Shadrach, Meshach, and Abednego in the furnace. "A coal," said Cooper, "has bounded across the room from Jones's picture and set fire to Turner's sea." The great man did not come again into the room for a day and a half; and then, in the last moments that were allowed for painting, he glazed the scarlet seal he had put on his picture, and shaped it into a buoy.[127]

But more than mere rivalry was involved. Turner on these Varnishing Days at the Royal Academy and the British Institution anticipated in his way Action Painting, which was to appear more than a century later. He demonstrated the importance of the act of painting itself, the significance of the artist putting pigment on canvas in the process of creation. At both exhibitions he had an audience of colleagues to watch and applaud his virtuosity. An exceptionally reticent and secretive man, at exhibitions he became an exhibitionist.

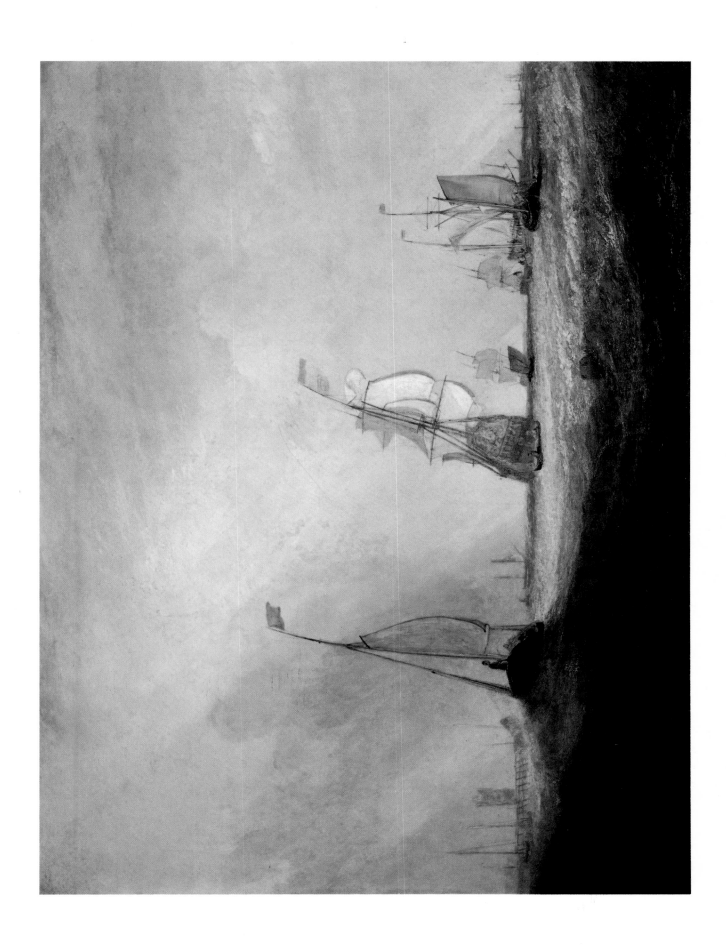

REGULUS

Exh. Rome, 1828–29; British Institution, 1837

Oil on canvas, 35¾ x 48¾" (91 x 124 cm.)

Tate Gallery, London

In 1828 Turner decided to spend some months in Rome. According to Sir Charles East-lake, he began "eight or ten pictures and exhibited three [one of them *Regulus*] all in about two months or a little more." But "the pictures...were in fact not finished; nor could any of his exhibited pictures be said to be finished till he had worked on them when they were on the walls of the Royal Academy."[128] *Regulus* was completed almost ten years after it was begun, in 1837, when it was shown at the British Institution. There is a painting by Thomas Fearnley showing Turner at work on the picture (fig. 30), as well as the following description by Sir John Gilbert, which complements Rip-pingille's accout of the artist's technique.

He had been there [at the British Institution] all the morning, and seemed likely, judging by the state of the picture, to remain for the rest of the day. He was absorbed in his work, did not look about him, but kept on scumbling a lot of white into his picture —nearly all over it. The subject was a Claude-like composition, a bay or harbour— classic buildings on the banks of either side and in the centre the sun. The picture was a mass of red and yellow in all varieties. Every object was in this fiery state. He had a large palette, nothing on it but a huge lump of flake white; he had two or three biggish hog tools to work with, and with these he was driving the white into all the hollows, and every part of the surface.... The picture gradually became wonderfully effective, just the effect of brilliant sunshine absorbing everything and throwing a misty haze over every object. Standing sideway of the canvas, I saw that the sun was a lump of white standing out like the boss of a shield.[129]

With time, however, the embossed sun has sunk in, or has been flattened out by some reliner, but the blinding, dazzling sunlight remains. This is the real motif of the paint-ing—the effect on one's eyes of staring for any length of time directly into the sun. But Turner needed a subject—something people would recognize and accept. A purely ab-stract study of brilliant light would have seemed bizarre and aberrant. He turned again to the Punic Wars, and depicted an episode from the life of Regulus, the Roman general who was defeated by the Carthaginians in 255 B.C. Sent to Rome on parole to negotiate peace, Regulus advised the senate not to accept the enemy's terms, and then returned to Carthage, refusing to break his parole. His troops are shown embarking on the return voyage. He was subsequently tortured to death by his captors. The tragedy ap-pealed to Turner's pessimism, for he saw in the fate of Regulus a further example of "the fallacies of hope," the title of his unfinished poem.

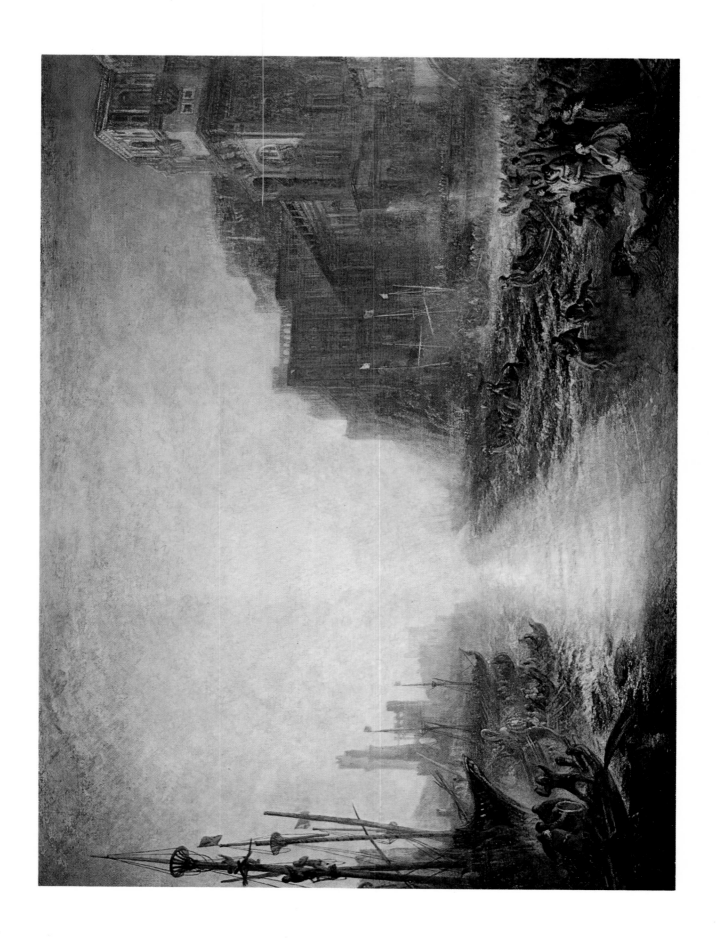

A HARBOUR WITH A TOWN AND FORTRESS

c. 1835-40. Oil on canvas, 67¾ x 88" (172 x 225 cm.)

Tate Gallery, London

This is the first reproduction in this volume of one of Turner's "unfinished" and unexhibited pictures. The subject, a harbor scene, and the general composition resemble two earlier works already reproduced, *Dido Building Carthage,* 1815 (colorplate 13) and *Regulus,* begun 1828 (colorplate 22). But the effect is totally different. In *Dido Building Carthage*, everything in the foreground and middle distance is in sharp focus. We feel ourselves admirers of the majestic palaces and temples under construction. The physical eye and the mind's eye join to give reality to this representation of a fanciful city as splendid as any conceived by man. In *Regulus* the dazzle of sunshine tends to blur the view; nevertheless, in the shadow of the noble edifices that line the harbor, we still feel ourselves a part of the jostling throng which watches the Romans embark.

A Harbour with a Town and Fortress is less conducive to empathy. Indistinctness has increased until the effect is that of a vision, as though some remnant of a dream remains embedded in the memory, some vague fantasy of towering houses with a vast citadel looming over hulks of amorphous shipping. Subject matter, an important element in the first two pictures, is almost nonexistent.

Had Turner shown *A Harbour with a Town and Fortress*, it would have been damned by the critics. Victorian taste wanted pictures with literary or historical references, such as *Dido* and *Regulus*. Yet to many people today this painting will seem the most appealing of the three. We are accustomed to pictures with no anecdotal content. We enjoy harmonious arrangements of color whether or not representation is involved. Here, gold and rose, purple and blue, a play of warm and cool tones, are seen under intense sunlight. Such a chromatic symphony is the raison d'être of Turner's canvas. There are people at the water's edge, wearing every kind of costume, but they have no significance except as accents of color, balancing the ships on the other side of the harbor. All intellectual references are removed and only the visual senses affected. The aesthetic response is at one level rather than at several.

In our time abstract art has placed such emphasis on form that content has virtually disappeared, at least in the work of the most significant painters. But Turner, in the pictures he exhibited and looked upon as "finished," stressed content. In conceiving these canvases, there seems to have been in his mind some symbiotic relationship between painting and poetry. It is difficult to believe he would have foreseen that his fame would depend to the degree it does on his unexhibited canvases, on those experimental abstractions, or "Color Beginnings," which were deemed by Turner and his contemporaries "unfinished," and one can only wonder what he would have thought of the work of artists today who look on him as their progenitor. But whatever Turner might have thought, the six reproductions that follow and the four at the end of this volume are the pictures which certainly speak to us most directly and offer to many the greatest delight.

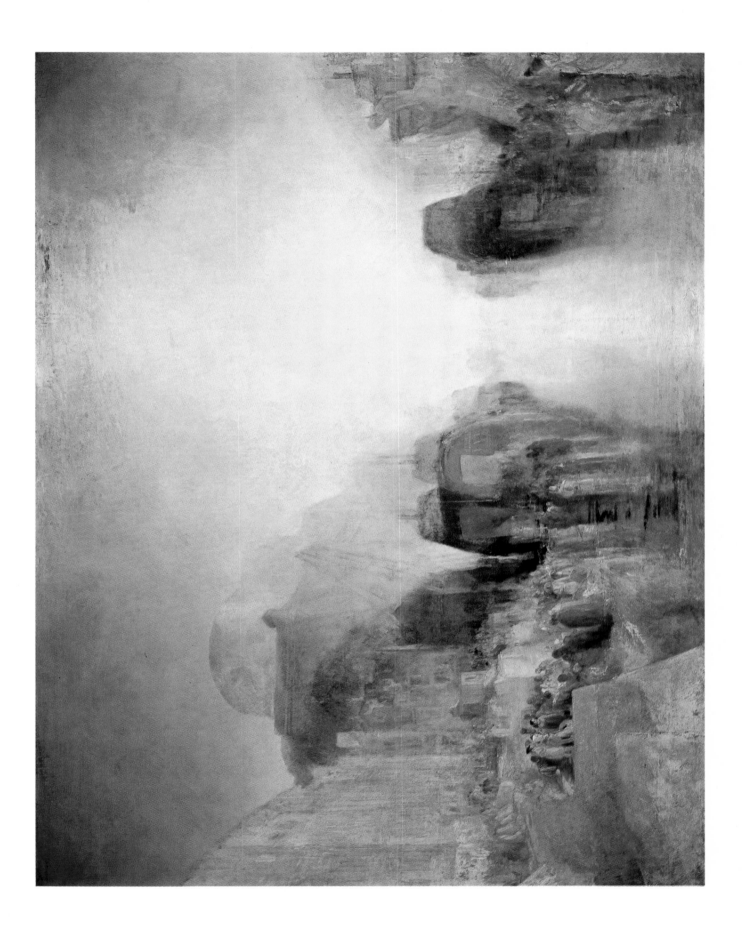

SUNRISE, WITH A BOAT BETWEEN HEADLANDS

c. 1835-40. Oil on canvas, 36 x 48¼" (91.5 x 122.5 cm.)

Tate Gallery, London

Nothing like the pictures reproduced in colorplates 23-29 would be painted for over a hundred years. In *Sunrise*, for example, using a few touches of blue on one side, some dabs of ochre and russet on the other, Turner has created a work which could be shown with the canvases of any Abstract Expressionist. If, however, he had hung it at the Royal Academy, even those who thought him sane would have questioned their judgment, and those who considered him mad would have believed they had absolute proof. But did he himself look upon such semiabstractions as exhibitable works of art? Important aesthetic problems are involved. The most fundamental is: who is the best judge of an artist's work, the artist or posterity?

Turner seems to have valued only his "finished" pictures. These were the ones he left to the nation. No mention is made in his will of what was to be done with the "unfinished" pictures; though Finberg says there are memoranda, not incorporated in any legal document, indicating that Turner at one time considered the possibility that "four different selections of his finished pictures might be exhibited annually, that a selection of his unfinished canvases might be shown in every fifth year, and a selection of his unfinished drawings and sketches every sixth year."[130] If such memoranda exist (I have been unable to find them), it follows that the artist wanted his finished work permanently on view and his unfinished pictures to be seen infrequently. I think it is likely that he intended his sketches and more cursory paintings to remain in his Queen Ann Street house; but the executors in their settlement with the next of kin gave away the house unconditionally, and the Trustees of the National Gallery took possession of all the pictures.

When the booty arrived at the National Gallery, Sir Charles Eastlake and the assessors of the court gave inventory numbers to the canvases they considered finished. The other paintings were put aside and forgotten. Some were finally resurrected at the beginning of this century, but Kenneth Clark reports that "as late as 1939 about fifty more Turners were discovered in the cellars of the National Gallery, rolled up, and thought to be old tarpaulins."[131] This is shocking but not surprising, for Eastlake considered such pictures "unfit for public exhibition, as being unfinished, and therefore only of interest to artists, to whom a reserve might advantageously be displayed."[132] Always provided, of course, that anyone were permitted to unroll these bundles of "old tarpaulins" rotting away in the cellar! Eastlake's wife, the former Elizabeth Rigby, if consulted, might have given him better advice.

LANDSCAPE, WITH WATER

c. 1835-40. Oil on canvas, 48 x 71¾" (122 x 182 cm.)

Tate Gallery, London

This is another picture which was rolled up and stored by Eastlake and the Trustees of the National Gallery. Judging by the high inventory number, 5513, the painting's rescue from oblivion has been recent. Why was it left incomplete, if indeed it *is* unfinished? Why was it ever begun? If Turner painted it for his own pleasure, if some day he thought it would be appreciated, if he wished to be judged as an artist by such partially abstract statements, then one would have thought there would have been some testamentary disposition of this canvas—and of the many others judged by his contemporaries so cursory as to be harmful to his reputation. He seems, however, to have made no legal provision for their future. Doubtless he wanted them preserved, but how or where is not at all clear.

Nevertheless, this does not mean that *Landscape, with Water* was painted with no purpose in mind. It is, I believe, one of the canvases the artist intended to take to the Royal Academy on Varnishing Day. We have seen how Turner astounded his colleagues by transforming such sketches, while they were hanging on the wall, from what Rippingille described as ''a mere dab of several colors, 'without form and void,' like the chaos before the creation,''[133] into finished paintings he was willing to exhibit to the public. He must have had innumerable lay-ins (the underpainting, embodying his concept of the scene) like this, and when the annual Academy show was about to be installed, he undoubtedly looked them over and decided which ones were worth completing. It is important to remember that the corpus of his work is enormous. His inspiration, unlike that of many other artists, rarely flagged; there was never a slackening of energy; he did not understand failure, his riches were infinite. His problem was to choose.

But it troubles us that what we greatly value, these incomplete canvases, may have been only a means to an end, the first stage before the finished, exhibited picture. If so, we may have made Turner over into our own image, accepting what we admire, rejecting what bores us, when he was actually a different kind of painter, one in advance of his generation but also one prepared to acquiesce to a great extent in the aesthetic standards of his own time.

What does this signify? To know that taste has changed does not enhance the beauty of the finished pictures, nor does it tarnish the loveliness of those deemed unfinished. Our response to both will always depend on our predilections. Significance there is, nevertheless. For if my assumptions are correct, they indicate that an artist may create unwittingly work more desirable in the opinion of subsequent generations than the work he himself esteems. And from this a dreadful consequence may follow. The artist, influenced by contemporary fashion, may disfigure the very beauty he has achieved. How often, one wonders, did this actually occur in Turner's work at the Academy on Varnishing Day? *Norham Castle,* the next reproduction, though without a blemish in my opinion, would, in that case, owe its sheer perfection to an element of luck.

NORHAM CASTLE, SUNRISE

c. 1835-40. Oil on canvas, 35¾ x 48" (91 x 122 cm.)

Tate Gallery, London

To our eyes this is one of the most beautiful of Turner's paintings. The subject itself appealed to him from his earliest days. In 1798 he showed at the Academy a watercolor of the same scene, and it was an immediate success. Many years later, according to Thornbury, as Turner passed Norham he "took off his hat and made a low bow to the ruins. Observing this strange act of homage Cadell [the Edinburgh bookseller who was his companion] exclaimed, 'What the devil are you about now?' 'Oh,' was the reply, 'I made a drawing or painting of Norham several years since, it took, and from that day to this, I have had as much to do as my hands could execute.' "[134]

The picture reproduced is the final outcome of a series of more than twenty versions in pencil, watercolor, and engraving. (Figs. 8, 47, and 51 show three from the years c. 1798, c. 1815, and 1834.) In *Norham Castle, Sunrise*, the last of all, forms seem to have been dematerialized in the effulgent light. The French artist Paul Signac praised it ecstatically, saying that in comparison with the earlier versions, it was "simplified and stripped of all that is useless."[135] And it is true that the painting has been carried to a point where another stroke of the brush could only cause damage. Fortunately the artist did nothing to disfigure his creation. But the nagging problem remains, was it providence that prevented Turner from adding more detail, from making these picturesque ruins more specific topographically, from destroying their abstract beauty? With so many canvases lying around the studio, was this one spared from Varnishing Day by the merest chance?

It has been persuasively argued that Turner felt as we do the beauty of the painting and therefore stopped at the right moment. This may be correct. How do we know? But even if we assume that Turner enjoyed looking at the picture in its present state, we are confronted with a further question: did he intend anyone else to enjoy it? There are grounds to believe that he did not! The evidence is the cliff below the castle where rivulets of blue paint have trickled down the canvas. I cannot believe that Turner anticipated not only Abstract Expressionism but also the more recent Drip School, and that he foreshadowed artists like Sam Francis. If *Norham Castle* were a painting he intended to be exhibited during his lifetime or after, he would surely have removed these driblets, made them more congruous with other areas of the picture. He was a precursor of modern art, but not *that* much of a precursor!

VAL D'AOSTA

c. 1836–37. Oil on canvas, 36⅝ x 49⅝" (91.5 x 122 cm.)

National Gallery of Victoria, Melbourne

In 1836 Turner set off on a sketching tour on the Continent with H.A.J. Munro of Novar, a wealthy Scottish landowner who was also an amateur artist and a collector of Turner's paintings. After visiting a number of picturesque sites in France and Switzerland, they went down the Val d'Aosta to Turin. In the Aosta valley Turner made numerous colored drawings, many of them from places that could be reached only on foot by strenuous effort, feats of mountaineering remarkable in a man over sixty. This painting was probably made from one of these sketches.

Theoretically, every work of art by Turner remaining in his studio formed part of the Turner Bequest and ended up in the National Gallery. But two of the finest of Turner's unfinished paintings, this one and *Landscape with a River and a Bay in the Distance* (colorplate 28), somehow escaped the ignominy of the storage rooms. Perhaps both pictures remained with Sophia Booth and were left to her son, John Pound, who, we know, sold a number of works by Turner. Eventually the two paintings entered the collection of a Frenchman, Camille Groult, one of the greatest nineteenth-century collectors.

Fine as most of the Groult paintings were, his "Turners" were a mixed lot. René Gimpel, the art dealer, says that three out of four were fakes, but that their owner knew what was genuine. Groult found amusing, however, the admiration for these daubs expressed by his visitors, who were fearful of offending him. He even gave one to the Louvre. The curators, not wishing to seem ungrateful, hung it at once, for they hoped he would leave them his collection. After Groult's death, when no bequest resulted, the fake Turner was promptly withdrawn. But hope springs eternal in the breasts of museum curators, and it was decided that "La Veuve Groult" might be more generous. The so-called Turner was rehung, but when Mme Groult died, the results were no better. Back to storage went the canvas, this time permanently.[136]

There is no question, however, of the authenticity of this mountain scene and the landscape reproduced in colorplate 28. *Val d'Aosta* is closely related to *Valley of Aosta—Snow Storm, Avalanche, and Thunderstorm* (fig. 25), which is now in the Art Institute of Chicago. One may deduce that Turner had in his studio two lay-ins of the Valley of the Aosta. Having to choose between them, he rejected the picture reproduced here, and instead completed the other preparatory sketch, probably on Varnishing Day. Once his selection had been made, the discarded lay-in was put aside. If the artist gave it to Mrs. Booth, he must have considered it of little value, for he was never very generous with his pictures; or perhaps, with commendable foresight, she purloined it.

A LANDSCAPE WITH A RIVER
AND A BAY IN THE DISTANCE

c. 1835–40. Oil on canvas, 37 x 48½" (94 x 123 cm.)

The Louvre, Paris

Even a museum curator will finally give up hope. With the death of Widow Groult, the Louvre at last decided to *buy* a landscape—the one reproduced here—from her heirs. Professor Michael Kitson, to whose articles I am much indebted, quotes a panegyric on this picture written in 1890 by the French art critic Edmond de Goncourt. The piece ends, ''Good Lord! It makes you despise the originality of Monet and the innovators of his kind.''[137] Goncourt's comments, Professor Kitson notes, were remarkably perspicacious for the time, but then Kitson goes on to point out that the writer's perspicacity is somewhat tarnished by a description ''equally enthusiastic of another Turner in the Groult Collection, *La Salute and the Palace of the Doges, Venice,* which is a notorious fake.''[138]

Although the Groult Collection was the source of many Turner forgeries, the authenticity of this lay-in, if that is what it is, is not in question, in part because of its intrinsic beauty, but also because before 1890 no one would have dreamed of faking so abstract a landscape. Nevertheless, the work's early history remains mysterious, as does the provenance of a dozen other late, unfinished works. How did these pictures, never exhibited or sold by Turner, become separated from his bequest? I have spoken of Sophia Booth's conceivable thievery, but there is another possibility. We know that at least twenty-four canvases found in Turner's studio were rejected by the National Gallery on the grounds that they were not by Turner. In accordance with the settlement of 1856 they went to the next of kin. Yet how unlikely that an artist would have had so many imitations of his own work lying around!

What was accepted or rejected among the unfinished pictures was decided by Eastlake and Prescott Knight, who compiled the inventory for the gallery. Their decisions may have depended on how dirty and unrecognizable the canvases were. A case in point is *River Landscape with Hills Behind* (c.1835–40), now in the Walker Art Gallery, an indisputable work by Turner done as a pendant to this painting. Until recently, when it was cleaned and it became clear that it was by the master, the pendant was labeled ''Turner School.'' Possibly the twenty-four canvases Eastlake and Knight discarded, had they been cleaned, might have been accepted as by the master. *Landscape with a River and a Bay in the Distance,* for example, has regained its pristine beauty, and one marvels at the way Turner has rendered the effect of sunlight dispelling the mist of early morning. But covered with dirt would any of these subtle gradations of tone, which make this painting so glorious, have been apparent?

The scene here, probably painted between 1835 and 1840, is the valley of the Severn and the Wye, and is related to the plate of this subject in the *Liber Studiorum* (fig. 41). All nonessentials—the figure, the castle, the trees on the left—have been omitted, but the main masses correspond. Turner has returned to a motif conceived in monochrome twenty years earlier and has translated it into a chromatic harmony of maximum brilliance.

INTERIOR AT PETWORTH

c. 1837. Oil on canvas, 35¾ x 48" (91 x 122 cm.)

Tate Gallery, London

This is one of the most beautiful and baffling of all Turner's works. Unlike many of his late paintings, which we consider unfinished, it is a picture one feels could never have been the initial stage of a canvas destined to be worked over while hanging on the walls of the Royal Academy. It is complete as we see it. A swirl of light and color painted with passionate emotion, it creates the effect of a remembered scene, as insubstantial and indistinct as a dream. Turner must have felt a wild desire to be liberated from the tedium of representation; and since we too are bored with the discipline of pictorial verisimilitude, such a painting speaks to us in a language we have come to accept with pleasure.

But was this picture something more, an experiment, an attempt to investigate a problem of vision? Here, recognizable objects are dissolved in streams of light which pass through the apertures of a large hall, a vast cube of space resembling nothing whatever at Petworth. There are glimpses of other rooms, also defined in terms of light. This blinding illumination turns the interior into apparent chaos, as though light rays had the power of dissolution. There is a clutter of details: a suggestion of a mirror, a dog, a catafalque with coat of arms (perhaps that of Lord Egremont, who died in 1837); but all are vague shapes with barely identifiable features. When the brain receives this inchoate data conveyed by the dazzled eye, its response is limited. The looking glass, the terrier, the coffin, which we can just discern in the painting, remain as they should, under the circumstances, indistinct and nebulous.

Turner was preoccupied with the mystery of sight. Complete darkness obviously prevents the eye from conveying anything to the brain. But light, if brilliant enough to dazzle, has the same result. Thus *Interior at Petworth* demonstrates that darkness and light have a similar effect on sight, both in their extremes breaking the connection between the eye and the brain.

An interpretation somewhat forced? Perhaps. Turner may have been merely experimenting with a picture dependent solely on color, as a musical composition depends solely on sound. He may have been orchestrating his favorite segment of the spectrum, yellow through red, and perhaps intended no more than a chromatic symphony in these tones. He apparently primed his canvas with vermillion, and then painted so rapidly that the pigment had insufficient time to dry. Wide separation cracks have appeared, and these have made crimson zigzags through the surface of this strange harmony of red, gold, and mauve.

But whatever Turner had in mind, he probably showed his picture to no one, certainly not to his host, Lord Egremont, if Egremont was still alive. The owner of Petworth, that eighteenth-century character, had he seen this weird representation of his mansion, might well have thought his guest insane and quickly terminated his hospitality!

JULIET AND HER NURSE

Exh. R.A. 1836. Oil on canvas, 35 x 47½" (89 x 120.5 cm.)

Collection Mrs. Flora Whitney Miller

In *Blackwood's Magazine* of October 1836, the Reverend John Eagles of Oxford wrote an article belittling the contemporary English School of painting and choosing as the object of particular venom Turner's newest canvas, *Juliet and Her Nurse*. "This is indeed a strange jumble—'confusion worse confounded.' It is neither sunlight, moonlight, nor star-light, nor fire-light, though there is an attempt at a display of fireworks in one corner. . . . Amidst so many absurdities, we scarcely stop to ask why Juliet and her nurse should be at Venice. For the scene is a composition as from models of different parts of Venice, thrown higgledy-piggledy together, streaked blue and pink, and thrown into a flour tub."[139]

The text of the seventeen-year-old Ruskin's counterattack, to which I have referred (page 26) and which he thought lost, was found among his manuscripts after his death. Ruskin first points out that, far from having shown various parts of Venice thrown together, Turner has given an absolutely accurate view, "taken from the roofs of the houses at the S.W. angle of St. Mark's place, having the lagoon on the right, and the column and church of St. Mark in front." And then Ruskin's irrepressible rhetoric bursts forth. "Many colored mists are floating above the distant city, but such mists as you might imagine to be aetherial spirits, souls of the mighty dead breathed out of the tombs of Italy into the blue of her bright heaven, and wandering in vague and infinite glory around the earth that they have loved. . . . And the spires of the glorious city rise indistinctly bright into those living mists, like pyramids of pale fire from some vast altar; and amidst the glory of the dream, there is as it were the voice of a multitude entering by the eye—arising from the stillness of the city like the summer wind passing over the leaves of the forest, when a murmur is heard amidst their multitude."[140] What eloquence! It is evident that Ruskin was as precocious in prose as Shelley or Keats in poetry.

Turner, however, try as he might, never achieved a command of words. Having received Ruskin's panegyric, he replied, "I never move in these matters—they are of no import save mischief and the meal tub, which Maga fears for my having invaded the flour tub."[141] This comment of Turner's is typically obscure, but was evidently intelligible enough to dissuade Ruskin from sending his article to *Blackwood's*. Nevertheless, Ruskin's "black anger" continued, and caused him to begin his major undertaking, *Modern Painters*. This monumental work justifies Oscar Wilde's splendid sentences, "Who cares whether Mr. Ruskin's views on Turner are sound or not? What does it matter? That mighty and majestic prose of his, so fervid and so fiery-colored in its noble eloquence, so rich in its elaborate symphonic music, so sure and certain, at its best, in subtle choice of word and epithet, is at least as great a work of art as any of those wonderful sunsets that bleach or rot on their corrupted canvases in England's Gallery."[142]

THE "FIGHTING TÉMÉRAIRE"
TUGGED TO HER LAST BERTH TO BE BROKEN UP

Exh. R.A. 1839. Oil on canvas, 35¾ x 48" (91 x 122 cm.)

National Gallery, London

Turner first painted this ship of the line in 1808 in his picture *The Battle of Trafalgar* (colorplate 8), where he described her as to be seen over the shattered stern of the *Redoutable*, "98 guns, Ad. Harvey (commanding), engaged with the *Fogieux* [sic], and part of the French line." While Turner was at Margate he may have seen the *Téméraire* being towed from Sheerness to Deptford to be broken up, and, deeply moved, painted a picture which has touched the hearts of generations of Englishmen since it was first shown at the Royal Academy in 1839.

The *Téméraire* has become a symbol of naval heroism. She was the second ship in the line of battle at Trafalgar. When she tried to pass the *Victory* to take on herself the fire directed at Nelson's ship, he told her to keep astern. She held back, receiving the enemy's fire without returning a shot. To quote Ruskin, "Two hours later, she lay with a French seventy-four-gun ship on each side of her, both her prizes, one lashed to her mainmast, and one to her anchor."[143]

Ruskin then concludes his account of Turner's *Fighting Téméraire* with one of the most beautiful paragraphs in English prose. "We have stern keepers to trust her glory to—the fire and the worm. Never more shall sunset lay golden robes on her, nor starlight tremble on the waves that part at her gliding. Perhaps, where the low gate opens to some cottage-garden, the tired traveller may ask, idly, why the moss grows so green on its rugged wood; and even the sailor's child may not answer, nor know, that the night-dew lies deep in the war-rents of the wood of the old Téméraire."[144]

William Makepeace Thackeray was as sentimental as Ruskin about the breaking up of the *Téméraire*. As usual he expressed the popular point of view. "The little demon of a steamer is belching out a volume...of foul, lurid, red-hot, malignant smoke...while behind it (a cold grey moon looking down on it), slow, sad, and majestic, follows the brave old ship, with death, as it were, written on her."[145] Such sentimentality was not in Turner's nature. If we look at his painting unemotionally, we can see that he wished to focus our attention on the tug. Turner has given the proud little steamer lines of grace and beauty, as she glides through the still sea like a black swan, towing the dim hulk of the warship. The calm of sunset evokes in the spectator a mood of tranquil melancholy, but it also suggests the end of one day and the beginning of another. Did Turner look on the tug as a symbol of the New World towing behind it the Old? Is it too fanciful to look on this seascape as a companion to *Rain, Steam and Speed* (colorplate 36), both harbingers of a new but not unwelcome era?

SLAVERS THROWING OVERBOARD THE DEAD AND DYING—
TYPHON COMING ON (THE SLAVE SHIP)

Exh. R.A. 1840. Oil on canvas, 35¾ x 48" (91 x 122 cm.)

Museum of Fine Arts, Boston

Henry Lillie Pierce Fund

Turner may have come to know William Wilberforce and the Anti-Slavery Society through their mutual friend, Walter Fawkes. The artist was certainly a supporter of abolition; and Graham Reynolds[146] suggests that in 1839 Turner, during what he considered a summer of idleness, may have perused Thomas Clarkson's *History of the Abolition of the Slave Trade,* the second edition of which appeared that year. There he would have read the terrible account of the slavetrader *Zong.* When an epidemic broke out, the captain ordered the sick and dying to be thrown overboard so that he could say they were lost at sea and claim insurance. On the ship they were not insured. Too many died that way!

The picture was also of topical interest: according to the original decree, the emancipation of the slaves in the British colonies, a process which had begun in 1833, was to have been completed by 1840. However, pressure on Parliament hastened the final stage by two years. Thus the public could look on this dreadful scene with a conscience recently cleared. As England was the leader in the abolition of slavery, a certain self-righteousness may not have been lacking.

Turner, however, was doubtless more interested in the opportunity the tragic event offered for a magnificent seascape than in the suffering of the Negroes. Ruskin, in discussing the picture, makes no direct reference to the drowning slaves, but he describes the sea as ''the noblest ever painted.'' He continues with another resplendent passage of English prose too beautiful not to quote at length.

The chief Academy picture of the Exhibition of 1840 . . . is a sunset on the Atlantic, after prolonged storm; but the storm is partially lulled, and the torn and streaming rain-clouds are moving in scarlet lines to lose themselves in the hollow of the night. The whole surface of sea included in the picture is divided into two ridges of enormous swell, not high nor local, but low broad heaving of the whole ocean, like the lifting of its bosom by deep-drawn breath after the torture of the storm. Between these two ridges the fire of the sunset falls along the trough of the sea, dyeing it with an awful but glorious light, the intense and lurid splendour which burns like gold, and bathes like blood. Along this fiery path and valley, the tossing waves by which the swell of the sea is restlessly divided, lift themselves in dark, indefinite, fantastic forms, each casting a faint and ghastly shadow behind it along the illumined foam. They do not rise everywhere, but three or four together in wild groups, fitfull and furiously, as the under strength of the swell compels or permits them; leaving between them treacherous spaces of level and whirling water, now lighted with green and lamp-like fire, now flashing back the gold of the declining sun, now fearfully dyed from above with the undistinguishable images of the burning clouds, which fall upon them in flakes of crimson and scarlet, and give to the reckless waves the added motion of their own fiery flying. Purple and blue, the lurid shadows of the hollow breakers are cast upon the mist of the night, which gathers cold and low, advancing like the shadow of death upon the guilty ship as it labours amidst the lightning of the sea, its thin masts written upon the sky in lines of blood, girded with condemnation in that fearful hue which signs the sky with horror, and mixes its flaming flood with the sunlight, and, cast far along the desolate heave of the sepulchral waves, incarnadines the multitudinous sea.[147]

After such a sublime paragraph it was only appropriate that the elder Ruskin should buy the painting and give it to his son on New Year's Day, 1844.

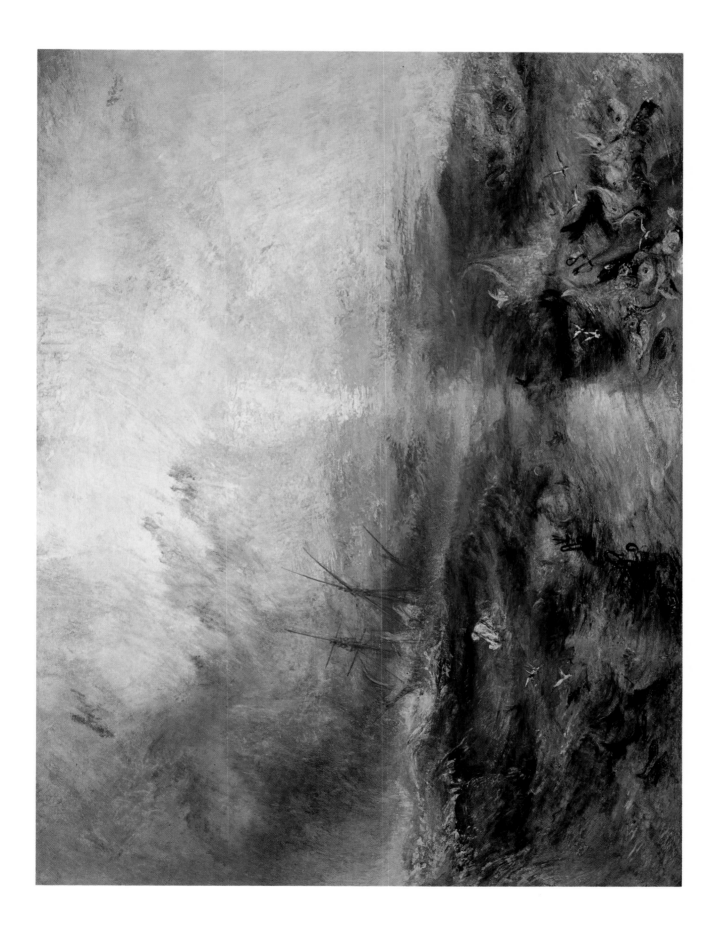

SNOW STORM

Exh. R.A. 1842. Oil on canvas, 36 x 48" (91.5 x 122 cm.)

Tate Gallery, London

Turner's pictures, even those that appear remarkably abstract, are generally based on a careful observation of nature stored away in his unique visual memory. This is clearly indicated by the full title he gave to *Snow Storm* when it was exhibited at the Royal Academy in 1842: *Steamboat off a Harbour's Mouth making signals in shallow water, and going by the lead. The author was in this storm on the night the Ariel left Harwich.* When the Reverend William Kingsley told Turner that his mother liked *Snow Storm*, Turner replied that he had painted it only because he wanted to show what such a scene was like. ''I got the sailors to lash me to the mast to observe it; I was lashed for four hours, and I did not expect to escape, but I felt bound to record it if I did. But no one had any business to like the picture.''[148] The critics cooperated. They disliked it! One said it was merely a ''mass of soapsuds and whitewash.''[149]

Turner was stung by this comment. He dined with Ruskin's father the day the criticism was published, and ''after dinner, sitting in his armchair by the fire,'' Ruskin said, ''I heard him muttering to himself at intervals 'Soapsuds and whitewash!' again and again. At last I went to him, asking why he minded what they said. Then he burst out. 'Soapsuds and whitewash! What would they have? I wonder what they think the sea's like? I wish they'd been in it.' ''[150]

Abstraction and representation, form and content, observation and the inner vision: the difficulty is to obtain a balance between these opposites. This Turner did repeatedly, and never with greater success than in *Snow Storm*. The rendering is remarkably abstract, yet one is almost overwhelmed by the dynamism of natural forces, by the terrifying storm, its turbulence seeming to suck the ship into a destructive vortex. Gone are the static architectural clouds of the early paintings. Instead, driving veils of mist lash the boat, impelling it toward the blinding light in the center. Gone are the waves with the roughly pigmented surfaces to be found in *Shipwreck* (colorplate 5) and *Calais Pier* (colorplate 4) of the beginning of the century. Now there are upheaving masses of water, great swells which pound and toss the ship with dreadful force. In the early seascapes, unity is obtained by repetition of shapes, the wave-shapes repeating the angles of the sails, of mast, boom, and gaff, and the clouds echoing the same forms. *Snow Storm* has a different type of design, one that Turner carried further than anyone before or since. He has created a swirling, twisting, integrated whole, a composition that passes the limits of Baroque art in its sweeping, rhythmic movement. Judged by the taste of today, this painting may well rank as Turner's most sublime achievement, at least among the pictures he exhibited.

SHADE AND DARKNESS:
THE EVENING OF THE DELUGE

Exh. R.A. 1843. Oil on canvas, 31 x 30¾" (78.5 x 78 cm.)

Tate Gallery, London

In 1843 Turner exhibited at the Academy two of the oddest yet most enthralling pictures he had ever shown—this painting and *The Morning After the Deluge* (colorplate 35). He had been reading Goethe's *Farbenlehre (Theory of Colours)*, recently translated by Eastlake, and though he had said in one of his lectures on perspective, "In these elevated branches of art, rules, my young friends, languish,"[151] still, as his annotated copy shows, he made a strenuous effort to understand the theory of color in this volume of obscure German aesthetics. Although the part of *Farbenlehre* which was based on experience rather than on mathematics appealed to him, as a professional painter he was skeptical of many of Goethe's assertions. He strongly disagreed with Goethe that the prejudice against theory common among artists was detrimental to practice. One can almost hear him muttering. "Prejudice of good more than evil," words he wrote in the margin.[152] But later he says that Goethe "leaves genius almost to herself here," and when Goethe gave yellow, Turner's favorite color, a dominant place in his theory, arguing that it was the first derivation of the highest degree of light and had a serene, gay, softly exciting effect, the painter was pleased. In the end he concluded, "Goethe leaves ample room for practice even with all this theory," and finally sums up by saying, "Yes, this is the tru[th]. Shot—but not winged the Bird."

Goethe based his analysis not on the spectrum, as Newton had, but on a chromatic circle containing what he considered "plus" and "minus" colors. Reds, yellows, greens were pluses, identified with emotions of happiness, gaiety, joy—all associated with warmth. Blue, a cold color, is related to darkness. Blue and its derivatives, purples and violets, suggest sorrow and dejection.

Whether Turner's *Deluge* pictures were intended to prove or disprove Goethe's theories is still debated. But there can be no argument about the mood of gloom they create. Kenneth Clark has noted that their whirlpool type of design expresses Turner's deep feeling of pessimism.[153] The vortex, basic in both compositions, thus stands for the tragic destiny of man, inescapably drawn into a vacuum. *The Evening of the Deluge*, with the water-laden sky curving over the earth and veils of rain sweeping across the landscape, conveys a feeling of impending destruction. As the procession of animals winds its way into the remote refuge, a flight of birds, forming another arc, recedes into the distance, increasing the sense of abandonment and desolation. The poem Turner wrote to accompany this picture is filled with foreboding.

The moon put forth her sign of woe unheeded;
But disobedience slept; the dark'ning Deluge closed around,
And the last token came: the giant framework floated,
The roused birds forsook their nightly shelters screaming,
And the beasts waded to the ark.

The Fallacies of Hope[154]

COLORPLATE 35

LIGHT AND COLOUR (GOETHE'S THEORY)— THE MORNING AFTER THE DELUGE— MOSES WRITING THE BOOK OF GENESIS

Exh. R.A. 1843. Oil on canvas, 31 x 31" (78.5 x 78.5 cm.)

Tate Gallery, London

It would be a welcome relief to say that *The Morning After the Deluge* lifts the atmosphere of doom conveyed in the preceding picture. True, Turner has employed predominantly Goethe's ''plus'' or vivacious colors, possibly because he wished to prove that warm colors do not necessarily express gaiety, happiness, joy, as Goethe thought. One feels little sense of elation looking at this second whirlpool, which pulls one toward the forbidding figure of Moses. Noah, who should have been the principal actor, would, if only because of his drunkenness, have been a more sympathetic apparition, but he is nowhere to be seen. In the center of the composition is the Brazen Serpent, the transformed staff of Moses. The staff may have been intended as a symbol of creation, but it also states the theme of the composition, the motif of its twisting, sinuous design. The earth-bubbles, to which Turner has given human features, are related to Goethe's theory that the origin of prismatic colors can be seen in the surface of a bubble. They also indicate the transitory nature of existence, as Turner's verse, which he published as the Royal Academy catalogue entry for the picture, makes clear.

The ark stood firm on Ararat; th' returning sun
Exhaled earth's humid bubbles, and emulous of light,
Reflected her lost forms, each in prismatic guise
Hope's harbinger, ephemeral as the summer fly
Which rises, flits, expands, and dies.

The Fallacies of Hope[155]

The poem provides further evidence of Turner's basic unhappiness. In Ruskin's words, ''With no sweet home for his childhood—friendless in youth, loveless in manhood—and hopeless in death,''[156] Turner was almost bound to become deeply pessimistic. This picture and *The Evening of the Deluge,* interpreted in the light of the poems Turner attached to them, are like those apocalyptic dreams which may reveal to a psychiatrist a patient's inner being. The shutter is suddenly raised and one has an insight, unexpected and unintended, into a closely guarded personality.

To quote again from Turner's most fervid and eloquent admirer: ''There never was yet, so far as I can hear or read, isolation of a great spirit so utterly desolate...Turner...saw no security that after death he would be understood more than he had been in life....Such praise as he received was poor and superficial....My own admiration of him was wild in enthusiasm, but it gave him no ray of pleasure; he could not make me at that time understand his main meanings, he loved me, but cared nothing for what I said.''[157] How this statement illuminates a double tragedy—Turner's and Ruskin's!

116

COLORPLATE 36

RAIN, STEAM AND SPEED—
THE GREAT WESTERN RAILWAY

Exh. R.A. 1844. Oil on canvas, 35¾ x 48" (91 x 122 cm.)

National Gallery, London

A marriage between Art and Industry: this was the hope of Victorian Enlightenment. But it never came to pass. Artists in general found the Industrial Revolution wholly repulsive, and industrialists, for the most part, found only the picturesqueness of the past appealing. Neither searched for beauty in the new Age of Steam. Turner was an exception. He admired modernity. *Rain, Steam, and Speed* states emphatically that a railroad train crossing a bridge is beautiful. The engine he selected for his painting was the most advanced type of locomotive of the day, known as the "Firefly Class"; and the bridge it is crossing at Maidenhead was a masterpiece of engineering by the greatest bridge-builder of his time, Isambard Kingdom Brunel.

Having journeyed all over England and Scotland and half of Europe in stagecoaches, Turner was among the first to welcome this speedier and more comfortable method of travel. He was particularly delighted by the Great Western Railroad, which opened its Bristol–Exeter extension in 1844, the year *Rain, Steam and Speed* was exhibited. On one of his trips on this railway, during a driving rainstorm, the artist saw a train approaching from the opposite direction. Leaning out of his coach window, he mentally photographed the scene, but when he painted this picture he characteristically took many liberties. Because he wished to have the oncoming train in the center of the bridge, he omitted the second track. He also wanted the black mass of the boiler broken up with light, presumably headlights. But the effect is that of a boiler being stoked, and thus the engine at first seems to be pushing, not pulling, its coaches. So that the spectator would know, however, that the train was moving forward rather than backward, Turner painted three puffs of steam, making the one nearest to the engine the most distinct, and the other two gradually less so. As a further indication of the direction of the train, he painted a hare running in front of the engine. Whether, as some have suggested, this is a symbol of Nature about to be destroyed by Industry, or whether, as I am inclined to think, it is Turner's method of indicating how slowly the train really ran, I leave to the reader.

Thackeray, reviewing the 1844 Academy Exhibition, wrote of the painting: "As for Mr. Turner, he has out-prodigied all former prodigies.... The world has never seen anything like this picture."[158] And up to the time of the Impressionists it is the solitary painting of significance glorifying the new age of railways.

SKETCH OF PHEASANT

c. 1815. Watercolor, 8¾ x 13½" (22.3 x 34.5 cm.)

Ashmolean Museum, Oxford

STUDY OF FISH

c. 1820–30. Watercolor, 9½ x 12" (24.4 x 30.2 cm.)

Ashmolean Museum, Oxford

An artist's technical skill is often to be seen most clearly in still-life painting. The beauty of such work depends entirely on pictorial elements: on the organization of tone, on the suggestion of texture, of volume, of pattern—all of them formal values. Turner's dexterity in handling these elements is shown by the sketch of a pheasant painted about 1815 in the difficult medium of watercolor. This sheet, which once belonged to Ruskin, may originally have been in the collection of Walter Fawkes, who commissioned a whole book of ornithological studies. When asked whether Turner had produced many pictures of birds, Ruskin replied, "Nowhere but at Farnley. He could only do them joyfully there!"[159]

Turner often shot over the Yorkshire moors with Walter Fawkes and his sons, but his gun was less effective than his rod. He was a passionate angler, carrying his tackle with him even on sketching expeditions, and was as at home fishing in the sea as in lakes and streams. He knew many sailors and seems to have rejoiced in their company.

The second watercolor reproduced, painted in the 1820s, is a study of plaice, shrimp and other fish, particularly of a John Dory. This picture also belonged to Ruskin and was also given by him to Oxford. Like the *Pheasant,* it is one of Turner's rare still lifes. Ruskin, lecturing to his Oxford students, compared it to a Japanese ivory and displaying it, said, "Here is, indeed, a drawing by Turner, in which, with some fifty times the quantity of labour, and far more educated faculty of sight, the artist has expressed some qualities of lustre and colour which only very wise persons indeed would perceive in a John Dory."[160]

This horribly ugly denizen of the ocean, which occupies the center of the watercolor, must have become fixed in Turner's memory and imagination. For its hideous appearance inspired one of his unexhibited oils, *Sunrise with Sea Monster* (c.1845), which he painted at the end of his life. In this late canvas, the John Dory's grotesque image, only slightly changed from the watercolor, rises from the waves, seemingly a symbol of the indwelling spirit of the sea, of its cruelty and destructiveness. Here, in a way, is the artist's final allegorical comment on the subject he often represented—the heroic struggles of men sailing their fragile vessels in overwhelming storms. *Sea Monster* is a picture Joseph Conrad would have fully understood.

THE GATE HOUSES

c. 1820. Watercolor, 12 x 16½" (30.2 x 41.9 cm.)

Collection Nicholas Horton-Fawkes

Farnley Hall, Otley, Yorkshire

THE CONSERVATORY

c. 1820. Watercolor, 13¼ x 16½" (33.6 x 41.9 cm.)

Collection Nicholas Horton-Fawkes

Farnley Hall, Otley, Yorkshire

Turner as architect! No one thinks of him in that role. Yet, according to Walter Thornbury, it was the career he almost chose as a young man. As a boy he worked in an architect's office, helping with renderings. When he became a successful painter, his architectural pursuits were abandoned. But the desire remained. His first efforts as a builder involved the remodeling of his house at 64 Harley Street to provide a gallery which would make him independent of the Royal Academy. Between 1819 and 1821 he built a second gallery in his house on Queen Ann Street, around the corner from the Harley Street house. He acted as architect and clerk of the works, and his sketchbooks are filled with notes on expenses: "paint, five pounds, carpenter's extra work, seven pounds, two shillings, six pence, Jones for watercloset, fourteen pounds." He even planned how to heat the gallery. These renovations kept him so busy that he had nothing to send to the Royal Academy in 1821.

Turner's most important architectural works, however, were his house at Twickenham, Sandycombe Lodge (fig. 18), which is still occupied, and two gate houses at Farnley, which he designed for Walter Fawkes and which are also still lived in. Sandycombe Lodge is a small suburban villa, far from impressive, and at first not particularly attractive. Yet the visitor of today will find it far more charming than the surrounding houses, which were built in this century. The plan, especially the shape of the rooms with their rounded ends, recalls the work of John Nash, a close friend whom Turner visited on the Isle of Wight; and the spiral staircase in the center of the house with its skylight, the favorite form of illumination of Nash's colleague Sir John Soane, must have been derived from Soane's house in London's Lincoln's Inn Fields, now the Soane Museum.

The first mention of Turner's designing architecture for someone else came from Effie Millais. She commented that he "had a fancy for architecture, but the lodges which he planned at Farnley are of a sort of heavy Greek design, and not quite a success."[161] The gate houses to which she refers are reproduced opposite. Each originally consisted of a square living room with a fireplace. Once more the work of Nash seems to have been the major influence. The proportions are excellent, Mrs. Millais notwithstanding, and the effect delightful.

Even more interesting as architecture is *The Conservatory*. This work is the equivalent of an architect's rendering, possibly intended to induce Walter Fawkes to build a greenhouse, though nothing was ever constructed. The concept of the building, with its thin members supporting panes of glass, must have been very advanced in 1820, the probable date of the watercolor. The stained-glass window at the end, which in Turner's time was actually in the music room at Farnley, is surely unique in conservatories. But Turner felt that the window's radiance would enhance the brilliant color of the flowers in the greenhouse, an appealing idea. Thus, even in designing a conservatory, he continued his unending search for new chromatic harmonies.

COLORPLATES 41 AND 42

EVENING: CLOUD ON MOUNT RIGI, SEEN FROM ZUG

c. 1841. Watercolor, 8½ x 10½" (21.8 x 26.8 cm.)

Ashmolean Museum, Oxford

BEAUGENCY

c. 1830. Watercolor, 4¾ x 7½" (11.8 x 17.5 cm.)

Ashmolean Museum, Oxford

Turner visited Switzerland repeatedly, and from 1841 to 1844 spent each summer there. Over the peaks and chasms of the Alps he watched for thunderstorms and whirlwinds that would demonstrate nature's violence, storing these impressions in his fantastic visual memory. But by the 1840s the fires of his earlier romanticism had died down, and in old age he looked on the beauty of the mountains with more detachment and more serenity. During this period he produced the watercolor depicting the huge bulk of Mount Rigi, which was as inspiring to him as Mont Ste. Victoire was to Cézanne. Turner has shown his favorite mountain at sunset, at dawn, against a clear sky, wreathed with clouds, and in every kind of illumination. According to Ruskin, he did this particular sketch for his own pleasure—a pleasure enhanced by the fact that the view could be seen from the window of his inn, Le Cygne, and could therefore be painted in the greatest comfort.

The day after he learned of "the death of my earthly Master," Ruskin wrote his father from Venice that now was the time to buy Turner's work.[162] "Invest in *mountain* drawings of any sort," he explained. "A mountain drawing is always to me worth three times one of any other subject, and I have not enough, yet. . . . Buy mountains, and buy cheap, and you cannot do wrong. I am just as glad I am not in England. I should be coveting too much—and too much excited—and get ill." The Turner bequest, however, was to frustrate Ruskin's greed. He was pained, he admitted, "at all the sketches being forever out of my reach." His pain, however, should have been assuaged by the sketches he already owned, among them this beautiful picture, a perfect example of pure watercolor, executed with the utmost rapidity and with no trace of a preliminary pencil outline. It depicts an awesome vision seen one evening—the vast silhouette of a towering escarpment looming out of the mist, a sublime record of a transitory inspiration.

Beaugency, by contrast, is not a random reaction to natural beauty. The artist painted it for a definite purpose: to provide an illustration for *Turner's Annual Tour*, the *Rivers of France* series. The book for 1833 was devoted to the Loire valley, and each watercolor was done to illustrate some picturesque scene or historic monument. These sketches display Turner's technical virtuosity. For the whole series he used a blue paper (now turned gray), spreading over it, where needed, delicate and transparent washes. These, with the untouched paper, create the effect of a sheet of calm water. To indicate reflections, he added a little more pigment, and for highlights, body color. To render architectural or other details and to strengthen outlines, he drew with a pen in reddish ink. In this way he provided all the scenic data needed for the illustration, though apparently the engraver was at liberty to make minor modifications. In the engraving of *Beaugency* (fig. 52) a second buoy has been added in the center, but it is doubtful that the composition is thereby improved.

STORM CLOUDS, LOOKING OUT TO SEA

1845. Watercolor and pencil, 9³/₈ x 13¼" (23.6 x 33.6 cm.)

British Museum, London

MONTE GENNARO, NEAR ROME

1819. Watercolor, 10 x 16" (25.7 x 40.5 cm.)

British Museum, London

In certain paintings, as we have noted, Turner seems to anticipate the abstractions of Rothko. Did he also foreshadow in others the hidden images of Salvador Dali? In *Storm Clouds, Looking Out to Sea,* with its menacing rainclouds, Martin Butlin sees "eagle wings hovering over the surface of the sea...evoking the helplessness of man before the forces of nature."[163] Certainly this is a provocative interpretation, but it is also possible to see in the sky on the left a multilegged, rather comical beast: the nose, mouth, eyes, rabbit ears, are clearly recognizable. It is amusing to try to find concealed figures in Turner's pictures. In *Calais Pier* (colorplate 4) there is a configuration of clouds, just above and to the left of the packet's mast, which suggests the head of a dragon in profile. It is as though the monster were blowing away the thunderheads to allow a patch of blue to be seen. In the *Destruction of Sodom* (fig. 11) clouds again combine to form the image of an angry old man with a pointed beard, perhaps God the Father punishing the sinful. And in *Cottage Destroyed by an Avalanche* (colorplate 10), rocks at the lower edge of the picture seem to form a gigantic recumbent statue broken at the neck, with the head in the right-hand corner of the picture and the breasts and part of the torso emerging from a blanket of earth—a suitable symbol of destruction.

Are these bizarre images really embodied in Turner's clouds and stones, or is seeing them a Polonius-like illusion? Francois Gilot recounts how Picasso told Braque that he could see a squirrel in one of the latter's Cubist pictures. Braque, in amazed distress, agreed, and spent days repainting his canvas to rid it of this unwanted animal. In Turner's work such touches of Surrealism, if they exist, may have been equally accidental. Or perhaps they were a product of his curious sense of humor. He loved jokes and, according to Ėffie Millais, when he told one he would laugh uproariously, place his finger to his nose, and look exactly like Punch.

But even the concrete objects in Turner's paintings, especially in the watercolors, are sometimes mysterious. What, for instance, in *Monte Gennaro, Near Rome*, is that thing seen halfway across the Campagna, rising out of the mist like the brown shaft of a column? It could be anything from Mrs. Lot in her saline state left behind by her fleeing family, an echo of the Destruction of Sodom, to the fragment of a ruined temple. But whatever this vertical accent is, the composition requires its presence. If you hold your finger over it, the landscape becomes as empty as a view on a postcard.

Turner was arbitrary in what he included or omitted in his pictures. He worked from memory, aided by pencil sketches made on the spot. His watercolors, for example, were painted in his hotel room or much later in his studio. They embody Wordsworth's "emotion recollected in tranquillity," such as Turner's response to the loveliness of Monte Gennaro rising out of the morning haze. They are representational only insofar as representation is necessary to convey the source of inspiration. As Turner said, "The only use of the thing is to recall the impression."

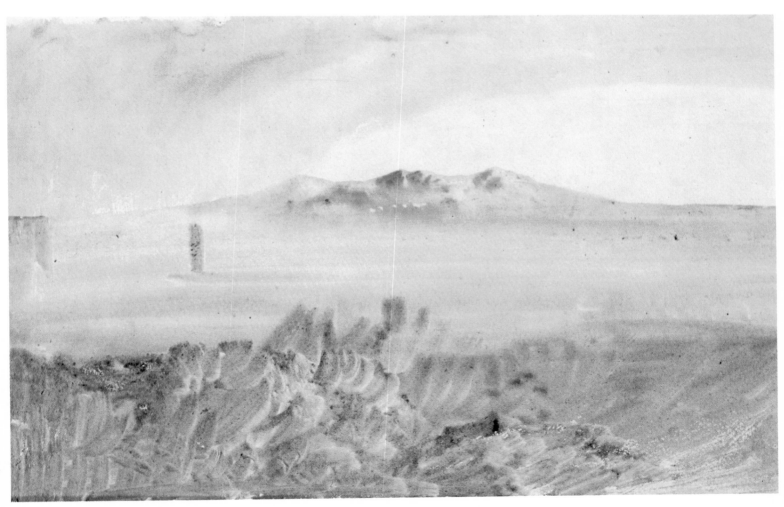

PHOTOGRAPHIC CREDITS

The author and publisher wish to thank the museums and private collectors for permitting the reproduction of paintings in their collections. Photographs have been supplied by the owners or custodians of the works except for the following, whose courtesy is gratefully acknowledged:

Geoffrey Clements (New York): colorplate 30; A. F. Kersting (London): fig. 27; Margate Public Library (Margate, England): fig. 31; Royal Academy (London): fig. 38; Tom Scott (Edinburgh): colorplate 11; John Webb (Cheame, Surrey): colorplates 1, 2, 3, 5, 6, 8, 9, 10, 12, 14, 19, 20, 22, 23, 24, 25, 26, 27, 29, 33, 34, 35, 43, 44; West Park Studio (Leeds): colorplates 39, 40.

The quote on page 18 is reprinted from Jack Lindsay, *Turner, His Life and Work*, Harper & Row Publishers, Inc., Icon Edition, 1971. © 1966 by Jack Lindsay.